745·5

883c !

745·5
renew this
further
not
another

D1583467

South Worcestershire College
Learning Resource Centre
Malvern Campus
Albert Road North
Malvern, WR14 2YH

Caroline
Broadhead

arnoldsche

Contents

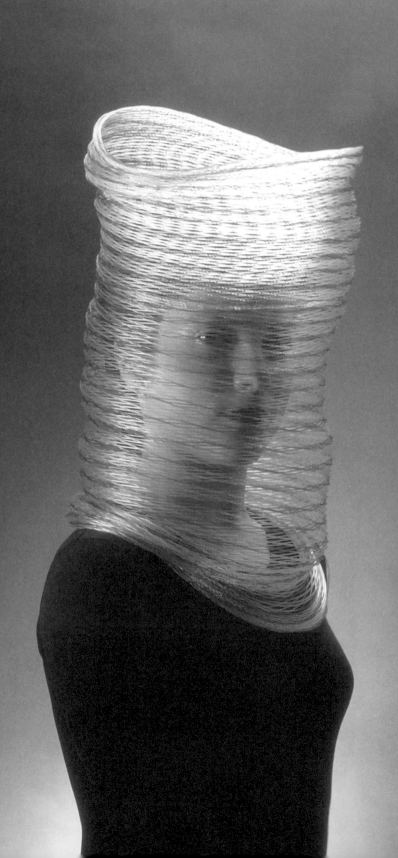

Liesbeth den Besten
Caroline Broadhead and the international 'objects to wear' movement

Some years ago I found an unpretentious book about Caroline Broadhead in a second-hand bookshop. *Jewellery in Studio*, published in 1990, was rather peculiar: its small paperback format and its unassuming design contradicted the adventurous jewellery and textile body pieces discussed in it. At the same time this publication gave a wealth of information on her work that had somehow slipped under the international jewellery radar since the mid 1980s. It is a document of a period in which Broadhead entered unknown territory, creating conceptual clothing pieces that found their way to photography and performances. In a short period of time her work moved away from jewellery and gained a performative character, somewhere in between object, clothing and dance: 'So, in a way I faded a bit at that time,'[1] she concluded. She made a step away from jewellery into the wider field of art, but it seemed so new – neither jewellery nor fashion – since there was no name for it nor an obvious place to exhibit it.

During this period her connection with the Netherlands was interrupted – a connection that had been so strong in the early 1980s that she came to work in Amsterdam because 'it had become the Paris or New York of the jewellery world, as London had been during Electrum's heyday. Now it was Galerie Ra acting as a focus and there were jewellers coming out of the woodwork all over the city!'[2]

Thanks to the visionary view of Jerven Ober (1942–2009), the director of the municipal Van Reekum Galerij[3] in Apeldoorn from 1976 to 1985, the work of Caroline Broadhead was introduced in the Netherlands, as part of the travelling exhibition *British Jewellers on Tour in Holland*. In his introduction to the exhibition catalogue, Ober mentioned the qualities of British jewellery: 'Across the Channel', he wrote, 'things are different: more varied, livelier, more colourful, often somewhat exotic, regularly pop-like.'[4] The selection, made by Jerven Ober, showed a variety of jewellery in non-precious materials that astounded the Dutch audience, who were used to a rather rigid geometric design methodology. In the same year, 1978, the travelling exhibition *Fourways* – about affordable jewellery multiples and organised by Caroline Broadhead, Susanna Heron, Nuala Jamison

5

and Julia Manheim – was held at Galerie Ra in Amsterdam. Yet Caroline Broadhead's textile and nylon jewellery stood out, the Dutch embraced its flexibility and exuberance, and in 1980 she had a solo exhibition at the Van Reekum Galerij. Her jewellery was subsequently acquired by Dutch museums and private people.

Since the late 1970s Caroline Broadhead has been at the forefront of conceptual making without initially being aware of it – her work is not based on a firm doctrine like that of her Dutch colleagues Emmy van Leersum and Gijs Bakker, who advocated their ideas about a revolution in jewellery loud and clear about a decade earlier. A generation behind them, Broadhead attended a lecture by them at Central School of Art and Design in London, where she studied from 1969 to 1972. She knew their *Clothing Suggestions* (1970), the seamless tight-fitting white stretch nylon suits with minimal integrated structures, a fusion of clothing and ornament. Yet Broadhead's textile body objects were about movement and intended to reveal the fathomless characteristics of being human.

After art school she started carving ivory necklaces that looked as if they were made from a soft material tied in a knot. Around 1976 she discovered ways to add colour to ivory, first by using ink, and then by adding multicoloured cotton threads. Coloured cotton flexible soft necklaces and bracelets followed. A next step was made when she started using tufted nylon in veneered wood with silver casings. Woven expandable necklaces and bracelets from nylon line, which she made in 1981 and 1982, opened new possibilities: they could act as a veil or, stretched horizontally, as large collars, or they could cover the arm entirely as a sleeve from wrist to armpit. In 1982, when she lived in Amsterdam on a Crafts Council bursary, she began to experiment with simple white fabric, creating shirts with very long sleeves. She exhibited these, together with her nylon jewellery, at Galerie Ra the same year. In the 1990 publication she says: 'I offered the shirts – I knew I was treading on terribly tricky ground – but Paul Derrez didn't mind. He accepted the work right away. Still, when I came back to England I really didn't know if the shirts were a mistake or not.'[5]

Apparently they were not. Broadhead continued working in this direction, creating white clothing objects with multiple sleeves, extremely stretched bodies and long sleeves, or instead indicating clothing, or the absence of a body, by making airy objects that only consisted of seams. With this work she moved to installation, performances and video – the work needed breath, movement and animation. Later she extended her vocabulary to chairs and other objects that could talk about the human state of being. Although Galerie Ra exhibited her conceptual work in 2000, it was clear that it was beyond jewellery and a genre in itself – a genre that only had a short-lived history in the Netherlands.

Nevertheless, her earlier work certainly boosted a shift in Dutch jewellery – it got quite some exposure through the Van Reekum Galerij, Galerie Ra and the Stedelijk Museum. On top of that the time was ripe. At the end of the 1970s Dutch jewellers like Marion Herbst (who had always resisted 'the Dutch school'), Maria Hees, Marga Staartjes and textile artist Mecky van den Brink had started making jewellery from textiles and (manufactured) soft materials (garden hoses, brushes etc.). Soon textile artists like LAM de Wolf and Beppe Kessler joined. At the height of this development, in 1983, the NKS (Dutch Art Foundation) organised a travelling exhibition about wearable objects by Dutch fashion designers and also by textile, jewellery and fine artists.[6] But far more remarkable was the collection of some one hundred objects by twenty-five international artists, curated by Susanna Heron and David Ward for the New York couple Malcolm and Sue Knapp, also in 1983.[7] This collection focused not solely on clothing objects and body pieces (by Caroline Broadhead, Susanna Heron, Julia Manheim, Pierre Degen, LAM de Wolf) but also on jewellery that invited one to think about the wearing of it: Emmy van Leersum's *Broken Line* jewellery, the *Hand Pieces* and elastic pins by Otto Künzli, the wrap around/ do-it-yourself arm pieces by Pierre Degen and Ruudt Peters. It made reviewer Graham Hughes sigh, 'This show sparks only on the art wavelength – performance, conceptual or what you will. Some of the attitudes expressed here to the idea of jewelry therefore seem to me a little too heavy for the medium.'[8]

The period is characterised by a spirit of exchange with many international jewellery exhibitions organised in Europe and abroad. The exhibition catalogues, including for *Jewellery Redefined* (1982), *Crosscurrents. Jewellery from Australia, Britain, Germany, Holland* (1984) and *Jewellery from Britain, Schmuck aus Deutschland, Sieraden uit Nederland, Juwelen uit Vlaanderen* (1985), show how jewellery with a textile or soft, flexible, performative and colourful character is prevailing. In Germany this tendency was less visible, but even the ambitious *Ornamenta* exhibition, organised by the Schmuckmuseum Pforzheim (1989), was somewhat affected by it. Eventually, because of the possibilities offered by other areas, such as clothing, performance, installation and sculpture, British jewellers began to follow different directions. While Caroline Broadhead's colleagues distanced themselves from it, Broadhead has continued teaching jewellery since 1986.

The 1980s can be observed as the period of 'objects to wear', with a strong emphasis on body-covering objects that questioned wearing and movement. But where Broadhead's conceptual shirts and dresses were close to clothing and the body, other European and American wearable objects were more related to ornament in the sense of being supplemental. Broadhead, using plain white textiles, made objects that dealt with use and the body: how to put it on, how clothing takes on the shape of the body, and how the body moves. This fundamental approach was far away from the Dutch objects to wear that celebrated the use of colour and of patterns (see the work of LAM de Wolf, Beppe Kessler, Joke Brakman and Claudie Berbee) as a liberation after the fundamental period of 'the Dutch school'. In the Netherlands the existence of excellent specialised and state-of-the-art contemporary jewellery galleries created a context for experiments in jewellery, but in the end there was no room for 'objects to wear'. It didn't really belong to the jewellery gallery and there were no other places where this work could be shown.

With hindsight it is interesting to observe that, in contrast to other countries, there was room for this new genre in Britain. Notwithstanding the obvious resistance it evoked (because it denied traditional craft values), it was recognised and appreciated as a conceptual offspring of craft, hovering on the borders of art. Thanks to a rich craft tradition and the existence of the national Crafts Council network that gave room for experimentation, Caroline Broadhead could freely investigate ideas about body shapes, contours, light and shadows, creating dialectic ephemeral craft objects that deal with the human existence. Since the aforementioned publication in 1990, which marked her first and rather insecure footsteps in a new realm that she partly invented herself, Broadhead has continued exploring the possibilities of wearing and the movement and change of her textile objects on the body. It ultimately brought her to dance, performance and spatial installations and offers a unique voice across the disciplines.

1 John Houston, *Jewellery in Studio. Caroline Broadhead*, London: Bellew Publishing, 1990, p. 40.

2 Ibid., p. 36.

3 In 1981 the gallery gained museum status and was called Van Reekummuseum. In 2000 the museum moved to a new building, where it is now part of a fusion between the city library and archives, under a new name, CODA.

4 *British Jewellers on Tour in Holland*, exh. cat., Apeldoorn: Van Reekum Galerij, 1978, unpaginated. The exhibition travelled to five cities in the Netherlands during 1978 and 1979.

5 Ibid., p. 40.

6 *Objekt en Image* (Object and Image) travelled to Dutch provincial and municipal art galleries.

7 The Knapp couple commissioned Heron and Ward to compose a jewellery collection for them. *The Jewellery Project* was exhibited at the Crafts Council Gallery in London in 1983. It led to heated reactions. See Peter Fuller's crushing review and David Ward's response in *Crafts*, no. 63 (July/August 1983), pp. 46–47 and p. 8.

8 Graham Hughes review in *American Craft*, vol. 43, no. 4 (August/September 1983), pp. 32–35.

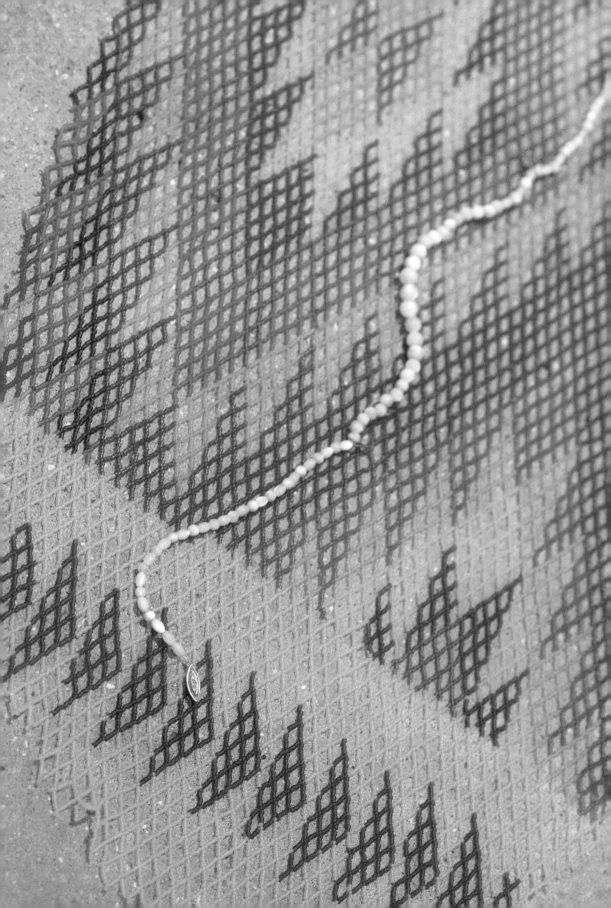

Jorunn Veiteberg
Emotional experiences

There's a pearl necklace lying on the floor. Is that accidental? Has somebody lost it? Or maybe deliberately left it there? For just a moment I'm taken aback by the sight of it before I realise that it's part of the exhibition I'm visiting. *Dropped Necklace* is the title, and on the information label a statement from the artist has also been printed: 'I am interested in the processes of loss and gain, abandonment and recovery, from first hand to second hand, from floor to skin, how an object accumulates a sense of history and what it might come into contact with.'[1] The statement could well be applied to many of Broadhead's pieces. They are often full of contradictions. At the same time as they can be sensed as physical materialisations in a space, they remind us of loss and absence.

To be able to study *Dropped Necklace* at close quarters we have to bend down to floor level. That does something to us. This is not the position we are used to taking in a work of art. Placing art on the floor is allowing it to be part of the world that we ourselves move around in. It removes the object from the protection which the pedestal or vitrine gives it and which serves to create a distance. We can easily step on or stumble over something lying on the floor, or simply overlook it. The floor position thus represents a loss of status and signals that this object might be considered worthless. The necklace is a second-hand find, and the pearls are imitations. A conventional necklace, in other words, placed on a surface that in terms of colours and patterns looks like a fragment of an Aztec carpet. As they are sewn together, anyone feeling like picking up the necklace gets the carpet into the bargain. 'In my narrative, the necklace has fallen on the floor, and when you go to pick it up, you also pick up the carpet,' she explained.[2] In this way she manages to show how things influence each other and how the identity of things can also be changeable. In addition she has been engaged in introducing an element of something unknown: 'It is about creating something that has an added dimension to it. [...] If the object is successful there is that interaction; it's about a second look, or a thought process, or an association that follows on from seeing it.'[3] As I see it, this is at the core of a great many of Broadhead's

9

Dropped Necklace (detail) 2015

projects: 'The function of my pieces has been to give the viewer or wearer a particular experience, or to start a train of thought.'[4]

That not everything is what it seems to be at first glance is a theme that often recurs in Broadhead's art. This applies quite physically in the form of pieces that play on illusionist effects, but it also includes more general questions such as: What categories do the objects belong to? Is *Dropped Necklace* a piece of jewellery, sculpture, installation – or perhaps all of these at one and the same time? She has not personally been interested in defining her works, but the openness towards various media has been perceived as a striking feature: 'Caroline Broadhead's work, in particular, has always been about dissolving boundaries.'[5]

What a closer inspection of *Dropped Necklace* will reveal is that the carpet fragment is not an Aztec but a net made of tiny glass beads, the making of which she learnt after a trip to Mexico. The jewellery conference 'Walking the Gray Area', held in Mexico in 2010, coincided with the ash cloud from the Icelandic volcanic eruption, which paralysed air traffic over large parts of the world. Following this, the curator, Jo Bloxham, invited several of the jewellers who had been stranded there to make a piece of jewellery in response to the experience. This resulted in her first beaded work, a self-portrait, which drew on the souvenir bracelets she had brought back. A number of works followed using this technique. The largest of these is *Blanket for a Foundling*. The Foundling Museum in London began life as a children's home established by Sir Thomas Coram in 1739. Parents who handed over a new-born child to the Foundling Hospital were encouraged to leave behind a piece of cloth or a small object that could be used to identify them if, some years later, they were to come to fetch the child again. The piece of cloth was often taken from their own or the child's clothing. The archive of these signs of attachment is a poignant source material and was an important inspiration for *Blanket for a Foundling*.

The beaded net blanket was made for an exhibition at the museum. In the blanket there is a large hole marked by a pearl necklace.

A part is missing; an empty space has been created. The foundling child got a roof over its head, food and schooling, but little love; they had no toys and were not encouraged to make friendships. For a time it was possible for the rich, for a sum of money, to be present during the selection of children to the institution. The blanket plays on the contrasts on which this system is based: the wealthy and the poor, the comfortable and the harsh. The point of departure was an unwanted necklace, of low origins, 'as an abandoned/rejected element as well as a representation of a token that the mother may have left'.[6] The beadwork, on the other hand, has connotations of wealth and prosperity, but a blanket of glass beads provides neither security nor warmth.

That something is missing is a theme in both *Dropped Necklace* and *Blanket for a Foundling*, but like the function of a piece of jewellery in old still-life paintings, the bead necklaces in these works can also be interpreted as a reminder of life's transience: a memento mori – a reminder that you will die. Jewellery is thus a concept that contains more than just serving as an adornment. Unlike many other jewellery artists, Broadhead asserts that jewellery can have other functions than being worn on a person's body: 'One function of jewellery is wearing, but it is also a means of communication – it can reveal what we hold to be valuable, for instance, social belonging, personal identity and beliefs, emotional connections and it can also be an exploration of objects that have a formal and abstract relationship with the body.'[7] By treating jewellery more as an attitude than a particular type of thing, she has made a rarely equalled contribution to enlarging our understanding of this medium. At the same time, this open and inquisitive approach has led to her own practice going in directions other than the production of jewellery, such as sculpture, installations and performance.

From items of jewellery to items of clothing

The breadth of formats and genres has meant that Broadhead has been called a 'highly versatile' artist.[8] But it started with jewellery. An early example is *Knot Necklace* from 1973. The material is ivory, but it looks more

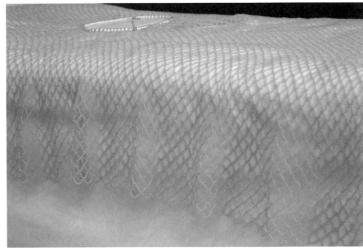

Blanket for a Foundling 2014

like textile: the hard bone has been carved to resemble a soft strand that has been tied in a knot. Already the flair for illusionist effects found expression here. The everyday function of a knot is to join and keep together; it is a universal symbol of binding. This could be seen either in a positive way or as something negative, such as a hitch or a problem that needs attention.

Ivory was also the main material used in the series *Broken Brooches* and the work *Drip Brooch*. These pieces play with the changes that can take place to an item of jewellery when it is used: it can get dropped and crushed, or it can melt as a result of the heat from a body. These brooches have retained their radical nature to the present day, but the pieces that have really given Broadhead

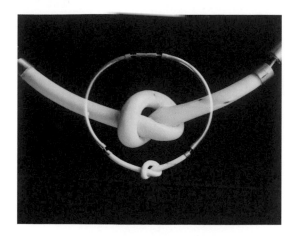

Knot Necklace 1973

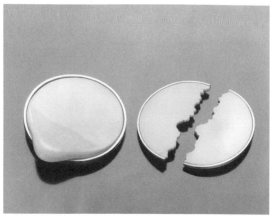

Drip Brooch and Broken Brooch 1973

a place in the history of art jewellery are those which she made after returning from a five-month trip to Africa in 1977–78. In particular it was the use that the Masai people in Kenya made of jewellery that made a deep impression on her: 'The jewellery they wore was so large, heavy and bold, so different from anything I'd seen in England, and it was the fact that these were items that were worn all the time – no discussion about wearability!'[9]

After her Africa trip she started to wonder about how she could fill in the intervening space between a circular form and the arm, and the answer proved to be a tufted bracelet made of wood and nylon filaments. As with the cotton pieces of jewellery made of tightly wrapped thread and soft tufts, she combined hard and soft elements in these bracelets. The nylon tufts *resemble hair*, and these long, soft threads stroke against the skin in a sensual way when worn. The contact between body and jewellery was important for Broadhead. Her jewellery explored how the pieces would feel or how they might inspire touch or handling.

The choice of thin nylon line meant a material that did not signal anything exclusive or expensive. It did not have any history either within the contemporary art jewellery movement that was beginning to have an impact in the 1970s and 1980s in Europe – 'Jewellery's *New Tradition*', as the writer and curator John Houston called it in a book about Broadhead.[10] This referred to the title of the

exhibition Broadhead curated in 1985 for the British Crafts Centre. This surge of activity was also called 'New Jewelry' by Peter Dormer and Ralph Turner.[11] Many of Broadhead's jewellery pieces are included in their important book from 1985. In the 1980s she started to weave tubular structures out of monofilament nylon. The result was pieces that could be stretched, so that they resembled veils, collars and sleeves. Especially *Veil*, a neckpiece from 1982, has become an icon for New Jewelry. This is not least due to the photograph taken by David Ward, where the neckpiece defies gravity and twists up like a transparent tube above the model's head. Apart from creating a space around the person, and in that way marking a boundary, the title points towards an item of clothing: the veil. The function of the veil is ambiguous. It is often used in seductive dance but is also a sign of virtuousness. Broadhead has claimed that *Veil* has to do with looking: 'Looking at, looking through and looking out'.[12]

Conceptual clothing

The transition from jewellery to shapes more like clothing took place gradually. Threads and textiles were already very much at the fore in her jewellery. Combined with her interest in the body and how we sense and move, it was logical to make pieces that covered even larger parts of the body. There were also other reasons why Broadhead was attracted to clothing as a motif. Familiar as all of us are with clothing, it is a good starting point for

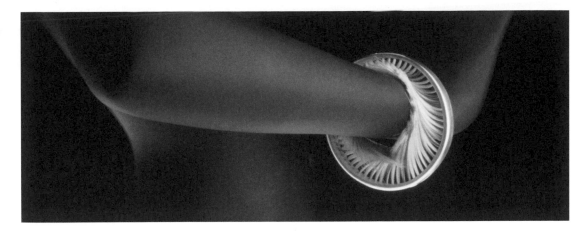

Tufted Bracelet 1979

communication. Clothes opened up a larger expressive register, and they could symbolise a whole person, not only part of a body. Even though removed from the body, an item of clothing can keep the memory of a person alive: 'Clothing holds a visual memory of the person and it is this closeness to the human being that I am interested in,' she said in an interview in the 1980s.[13]

The first series was based on a classic item of clothing, a white shirt: *Shirt with Long Sleeves*, *Wraparound Shirt* and *Shirt with Seven Necks* were some of these. As the titles show, these ordinary items of clothing are defamiliarised either by having more than two sleeves and one neckline or by the sleeves being made extra-long. By means of such surprising measures, states of a more emotional or existential nature were communicated. This became even more obvious when the shirts were used in a performance, as was the case in *Undercover*, which she carried out with Fran Cottell in 1989. The shirts had been made so that they could be worn, but their form required particular acts on the part of the wearer. To dress and undress are part of everyday rituals, but in the performance these acts took on a compulsive nature. *Wraparound Shirt* with its three and a half sets of sleeves, for example, formed just as many layers round the body, trapping the wearer almost like a straitjacket.

Initially the shirt objects were shown at jewellery exhibitions, but Broadhead felt that they disagreed too much with her own expectations of jewellery to belong to such a context. They were more wearable objects than jewellery, just as they were more clothing than fashion. 'Hybrid' was the word that was felt to be the most apposite in the 1980s. In the postmodern vocabulary of the time, 'hybrid' was a key concept which, with its bastard associations, involved an orientation towards more 'impure' and eclectic art forms. A number of jewellery artists were working at that time on including the body in new ways, either via performance or via large bodywork, where they employ the entire human frame – not just a neck or wrist – as a point of artistic departure. Broadhead was thus not alone in turning in this direction, but the problem of finding suitable arenas for showing this type of art was challenging.

The exhibition *Conceptual Clothing* at the Ikon Gallery in Birmingham in 1986 was therefore a very important one. It was the first time her works were shown in a different and larger context than that represented by jewellery. The exhibition discussed ways in which clothing was used as art, and the curators, Fran Cottell and Marian Schoettle, had invited both visual artists and craftspeople, twenty-three of them in all. The series *7 Ages* was Broadhead's contribution. The title has been taken from one of the famous speeches in Shakespeare's *As You Like It*, where the character Jacques describes the seven stages of human life: infant, schoolboy, lover, soldier, justice,

13

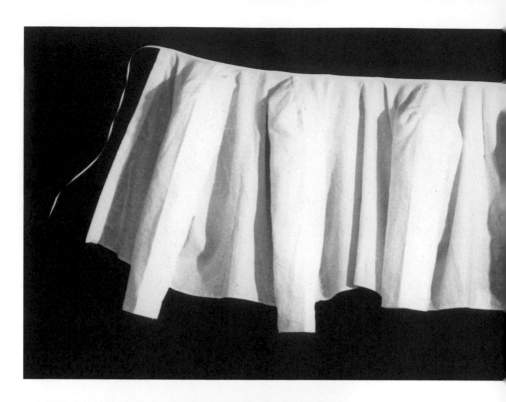

14

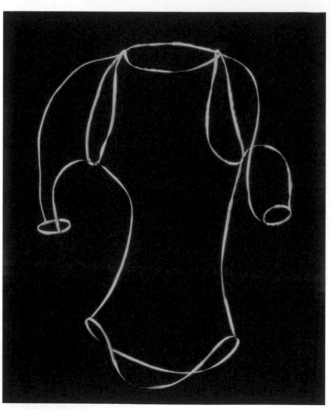

Wraparound Shirt 1983
Seven Ages 7: Seam 1986

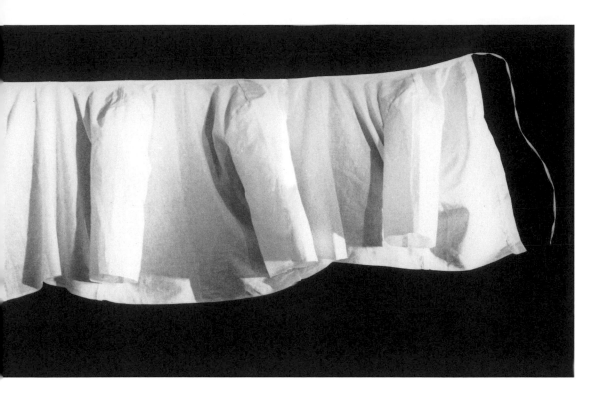

pantaloon and, finally, the second childhood, in which one is deprived of all senses and becomes nothing. Broadhead's depiction of the stages of life is seen from a woman's point of view. Each stage from embryo via motherhood to death is symbolised by a simple form, but one rich in associations, made of different white materials. The seventh item of clothing is called *Seam* and is more a drawing than anything else. Only the seams of the dress are left, and they make up the outline of a silhouette. The following year she made several variations on this motif. 'They are dynamic signs of a recent departure,' according to John Houston.[14]

At the exhibition *Addressing the Century: 100 Years of Art and Fashion* at the Hayward Gallery in London in 1998, a variant of *Seam* from 1989 was shown alongside Joseph Beuys's *Felt Suit* from 1970 and Christo's *Wedding Dress* from 1967. This is an interesting juxtaposition. *Felt Suit* deals with the warming properties of felt as a material, while *Wedding Dress* portrays marriage as a heavy burden for women. In Broadhead's work both material and motif create meaning, but in addition it has a sensual quality that was unusual in early conceptual art. So she has

contributed in this way to a more aesthetic turn in conceptual art, and this became even more evident in her production during the 1990s.

Broadhead often returns to former ideas. In 1997 she created a piece which instigated a claustrophobic-like feeling, relating to the smaller scale *Wraparound Shirt*. The dance performance *The Waiting Game*, at Upnor Castle in Kent, in collaboration with the choreographer Angela Woodhouse, consisted of various parts both outside and inside the castle, but a focus on one tableau is of particular relevance in this context. Performed in an almost square room, a female dancer stood in the middle of it dressed in a white linen dress that covered the entire floor like a carpet. In doing so she was defined by and bound to the room. Eternally waiting. The public had to tread on the dress-carpet in order to enter, which created an unpleasant feeling of invasion. This trespassing also anchored the dancer, which allowed her to move, pull and lean in ways that would otherwise be impossible.

The experiences with performances have been important for Broadhead on various

levels. Working with a time-restricted medium points forwards towards the installations that have become an increasing part of her practice since the late 1990s. The performance pieces have also enabled her to experiment more with space and movement in conjunction with textiles, which reached a highpoint with the *Breathing Space* installation in 2005 in York St Mary's, an arts venue in a deconsecrated church.

Symbolic dresses

A simple, classical dress shape gradually became a prime motif. 'It can represent the whole person in a way that no other form of garment can,' is one of the reasons she gave for this choice.[15] The dresses do not only serve as replacements for bodies but also mark the interface between the individual and the world. They are the façade, the exterior and the official side that can cover an interior of a completely different nature: 'Clothing's role [...] is to display a unified "identity" while in reality holding together an always fragmented "self",' Alison Ferry asserts.[16] By articulating the body, it also articulates the psyche. This is particularly evident in Broadhead's works from around the year 2000, in which the material, tulle, is completely transparent. The dresses in such installations as *Double Dresses*, *in-crease-de-crease* and *Eclipse* consist to a very small extent of fabric and material. They have broken free from all the references to women as flesh and bone in which art otherwise abounds. Instead they address issues of identity and mental states. This is further underlined by titles such as *Beside Myself*, *Suspend* and *Cornered*.

In exhibitions the dresses always hang freely. Grouped together into small and larger groups, in pairs or alone, they 'populate' the room. The craft expert Jeremy Theophilus has reflected on the distinctive experience this provides: 'By hanging/floating before us they become disconnected and inhabit a gravity-free zone.'[17] The illusion created by these classically-shaped dresses of a socialised, centred female subject is disturbed by other, formal devices that create fluid boundaries and which tend more towards dissolution and decentring. The most important device in this context is the use of shadows.

Shadows

It was in the mid 1990s that Broadhead started to explore the shadow via photography and drawing. This gradually led to installations where dresses of various materials had their shadow painted or drawn on the wall. The shadow is a potent symbol that may even be the mystical origin of the art of painting. According to the Roman Pliny's natural history from the age of antiquity, the art of painting arose when someone drew a person's shadow, thus creating an image of man. From the outset pictorial representation has thus been followed by an absence/presence theme: absence of the body/presence of the body's projection. The dialectic of this relationship runs like a filament through the history of art, and Broadhead has actively linked up with it.

Both the dress itself and the shadow of the dress are representations of the absent body, but the shadow has additionally a number of other meanings. In the book *Caroline Broadhead* from 2001, Jeremy Theophilus discusses many of these.[18] He claims that the shadow is often interpreted as a manifestation of the soul, or as a symbol of the dark and negative side of one's personality, the side one prefers to keep concealed. These are meanings that Broadhead has emphasised too while also pointing out that the shadow can represent a duplication and thereby can open up for the unknown: 'I have used the shadow to represent the darker side of somebody; there's the shadow of the person, but also that kind of slightly unknown, or doubling up of something, of the "other". But I think a shadow is slightly mysterious, and there's a distortion when it's translated into the two-dimensional.'[19]

The psychoanalyst Carl Gustav Jung regarded the shadow as man's instinctive and primitive side, a side that is both creative and destructive. No matter how we interpret the use of the shadow, Broadhead has found in it a metaphor that is rich in references. In *Back to the Wall* it is the shadow images that attract one's gaze, and not the thirteen dresses that cast them. The reason is that the shadows are filled out with dark colour, thus drawing attention away from the transparent objects across to the images of them. But images of

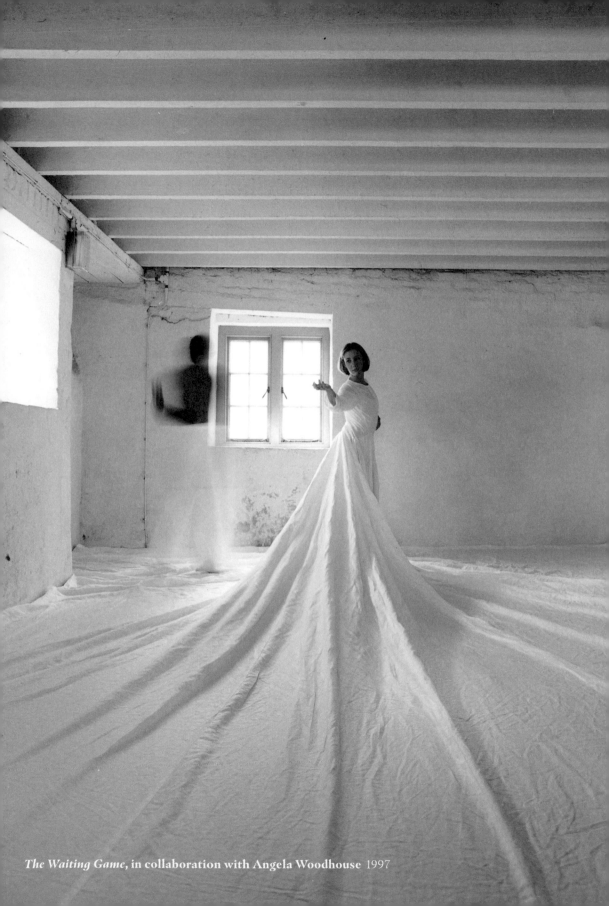

The Waiting Game, in collaboration with Angela Woodhouse 1997

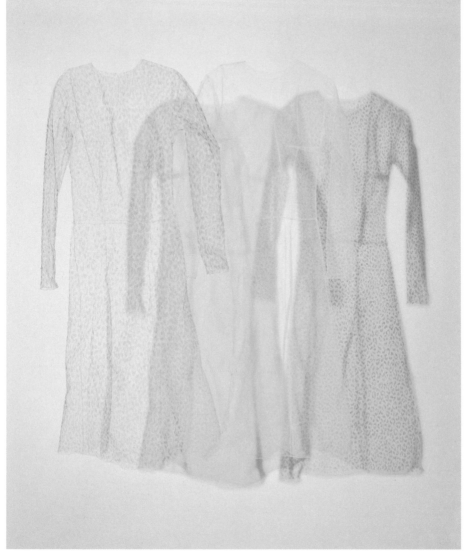

Double Dresses
2000

18

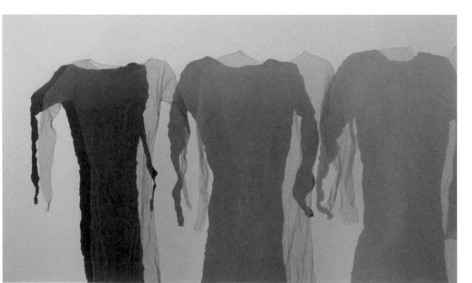

Back to the Wall
2001

what: the physical dress or the non-physical shadow, or both? The boundaries between the tangible and intangible, fixed and flexible become fluid. In this and other works featuring shadow, Broadhead has made the shadow a more important part of the work than the item of clothing casting the shadow. The reason for this is the wish to 'give emphasis to the hidden, non-existent and immaterial', and at the same time 'to view the shadow as a source of illumination'.[20]

Emotional engagement

The many installations with tulle dresses and shadows prompt us to ask what it is we actually see. Can we trust our visual impressions or is it all an optical illusion? That everything is not what it seems to be is certainly illustrated by the piece *Double Dresses* from 2000.

It consists of two dresses, one in plain white and the other in a grey leopard-skin pattern. The shadows are visible behind the transparent material. The shadow of the plain dress is drawn in pencil on the wall and provided with a leopard-skin pattern, while the shadow of the patterned dress is plain. The patterns of the leopard serve as a visual survival strategy. Wild animals evade discovery through their ability to blend in with their surroundings. In works like this one, Broadhead plays on camouflage as both useful protection and as a tactic to avoid revealing oneself. The fluid contours and the use of shadows are important means for creating a feeling of something non-static and changeable, while they also tell of a destabilisation of physical and mental boundaries.

Not all critics were equally positive when the earliest variations on this theme, as in *Over my Shoulder* and *Steppenwolf*, were shown at the exhibition *Bodyscape: Caroline Broadhead* in Angel Row Gallery in Nottingham in 1999. The exhibition received a somewhat slating review from Mary Schoeser in *Crafts*. She found it 'private, self-absorbed, even self-indulgent in its puzzling out of the meaning of dress'.[21] David Whiting's review the following year of the exhibition *Chiaroscuro* at the Barrett Marsden Gallery in London was otherwise

positive: 'Broadhead helps us to see the familiar with quite new eyes, to think about our marks and imprints, which, like our memories, can remain indelible or fade from sight.'[22] The similarity between the blurred motifs and how our memory works is an important point. Among the works on display in this exhibition was *Double Dresses*.

In the beauty and the frailty that permeate these works there lies a great potential for emotional engagement. The groups of transparent, human-like figures and their shadows show us that we humans are vulnerable. This is an important insight, one that is fundamental to our capacity for empathy. Perhaps this type of art can even offer consolation. In the novel *The Names*, Don DeLillo writes: 'Maybe objects are consoling. [...] Objects are what we aren't, what we can't extend ourselves to be. Do people make things to define the boundaries of the self? Objects are the limits we desperately need. They show us where we end. They dispel our sadness, temporarily.'[23] Broadhead describes the boundaries of the self as a form without fixed contours. Occasionally the forms overflow seamlessly into each other. The titles are the most important clues for demarcating the variety of possible interpretations, and they often point towards pressurised situations or ambiguities. A movement towards increasing or decreasing, visibility or fading out. The span between life and death is depicted via subdued effects, but silence is also eloquent.

In her essay 'The Aesthetics of Silence', Susan Sontag says that all noise, both visual and audible, that surrounds modern lives precludes thought and leads to even more noise. That is why the artist longs for silence, she claims.[24] Silence is what comes before and after speech; it is the contemplation that exists in the space between words. A striking work of art is one that leaves silence in its wake. Broadhead has created many such works. Or, as Steffan Jones-Hughes has formulated it: 'What is clear in the work of Broadhead is that that which is left unsaid, undone, sometimes has a potency whose reach far exceeds the structural.'[25] One of the least noisy of her works is the site-specific installation *Still Light*, which

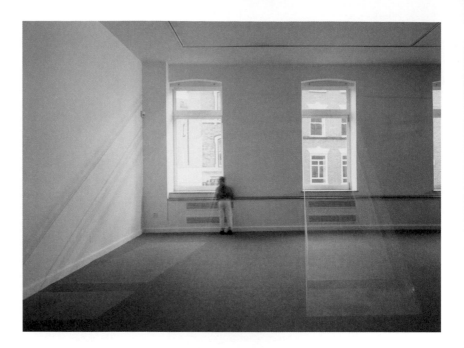

she made for the exhibition at the Angel Row Gallery in 1999. Light and shadow are still the focal point, but instead of the shadow it was light streaming in through the window that she was attempting to capture. 'I had been exploring shadows, thinking about the volume of shade as it formed a shadow. This piece used the idea of light as a volume, penetrating the building.'[26] The light from the sun or moon leaves behind illuminated sections in the room, which she emphasised in the installation by stretching hundreds of elastic and transparent threads between the window frame and the floor. In doing so transient and formless light was held fast during the period of time the exhibition lasted.

Still life
When asked what subject interests her, Broadhead answered recently: 'I'm interested in the surface, the silhouette, the way things are viewed. Layers, the double, objects in a state of flux, stability and instability, effects of light, elusiveness and intangible elements.'[27] She has constantly returned to these issues, but always in new ways.

In 2011 she and her daughter, the artist Maisie Broadhead, were invited to do a dual exhibition at the Marsden Woo Gallery (formerly Barrett

Marsden). With seven carefully selected paintings by Vermeer, Velázquez, Hogarth and Magritte as their point of departure, all of which included a significantly empty chair, they created independent but connected works. The exhibition *Taking the Chair* included Broadhead's reworked second-hand chairs, and Maisie Broadhead's photographs, which reinterpreted the paintings and integrated the chairs. Each chair was made in response to the paintings and its imagined role; one exposed its fragile nature, others were dressed up, another captured a child's chair within a tulle framework of the chair in the painting.

By reconstructing one chair in tulle, accentuating another's outline with polymer clay or covering another with bead embroidery, she was able to highlight the silhouettes of the chairs. Or, in Victoria Pomery's words, to 'transform their nature through this "soft-focus" approach'.[28] As with the items of clothing, an empty chair can symbolise an absent person. Broadhead's chairs invite similar metaphorical readings as the dresses do. The covering removes their function as a piece of furniture to sit on and transforms them into objects to look at, again referring back to their role in the paintings. As a press review from her gallery remarked:

20

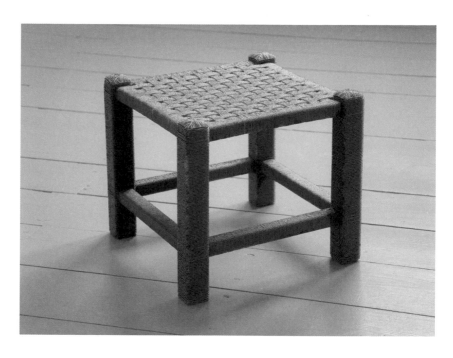

'For Broadhead, choosing existing pieces to remake captures them in a state of flux – somewhere between motion and stillness, real and implied.'[29]

At the exhibition, which Broadhead held in the same gallery with the jewellery artist Maria Militsi in 2015, she showed several stools. In *Still Life, Stool* an ordinary, square-shaped stool is used, but the seat is made of glass beads. The pattern of the dark and yellow-coloured beads is almost indistinguishable (at a distance) from wickerwork. Once more we are involved in a 'complex game of hide-and-seek'.[30] A game that requires a second look. Another stool was completely covered by a net of tiny glass beads. It was also at this exhibition that *Dropped Necklace* was shown for the first time. The combination of old and well-used stools and gleaming glass beads can be read as a contribution to a discussion about taste and values. It raises a question about the place and importance of decorative qualities in art.

A piece that contains a great many of the themes with which she has worked is *Exchange of Views* from 2006. It is made up of bits of mirror that have been fixed directly to the wall to create a decorative and at the same time fragmentary pattern of lace that has been strongly magnified. The mirroring effect makes it difficult to capture the reflected image in its totality. Every time we move, we have to decide whether to focus on the pattern or on the images reflected in the mirror fragments. The point of departure was Broadhead's fascination with the function of the cheap net curtains that hang in most windows in the part of London where she lives. They are to protect people's private lives by preventing one from looking in, but when it is dark outside and the lights are on indoors, everything inside can be seen through the nets. 'The idea of this piece was to create a spectacle of the very thing that is meant to deny one,' she explained.[31]

Originally lace curtains were made by hand, but with the industrial revolution machinery was developed for mass-producing them. That led to a fall in status. In *Exchange of Views* the production method is an important part of the work. The pattern was created digitally, but Broadhead hand-cut all the shapes out of acrylic to avoid machine perfection. In a way, by doing this she completed a circle of production, using an image from machine-made lace, which in itself is a reproduction of older designs, through a digital process and then back to hand-made.

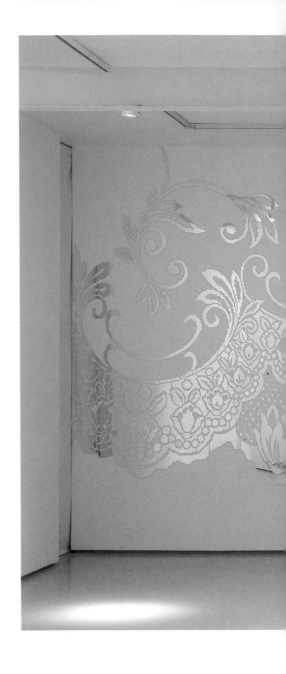

Repetitive work

To an increasing extent emphasis in the field of contemporary art is being placed on the production side of art. Broadhead invests a great deal of time in the work process. This represents a choice, just as it represents a choice to do this work herself. The bead embroidery, for example, requires concentration, but it is also work that with its repetitive actions has meditative qualities. To many people repetitive work processes have a negative ring. But that is often coloured by depictions of people standing at a conveyor belt and carrying out mechanical operations. The satisfying nature of sewing stitch after stitch or threading bead after bead is all about an organic rhythm and giving oneself time. Modern man only works with that which can be made quicker the poet Paul Valéry claimed a hundred years ago. Already back then he was able to confirm that making things that call for patience, diligence and hard work were gradually disappearing. What also disappeared was the joy of work.

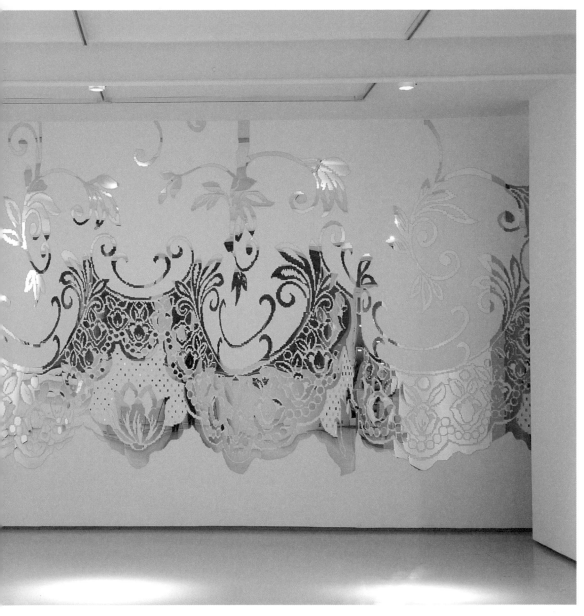

At various levels, Broadhead's art questions our system of values. She invests time in the making of her works but often uses cheap materials. Many of her pieces have been of a time-limited nature, while the installations have been taken down after the exhibition and packed away. She does not pander to the market either. What most interests her is to offer an experience. Performance and installations are well-suited for such a purpose. With the expansion of installation art, the exhibition as a medium has acquired greater importance. In many instances they are works of art in their own right. At exhibitions a direct encounter between viewer and work can take place, and Broadhead's art has to be experienced physically. The play of light and shadow and the subtle details discovered after closer scrutiny cannot be replaced by photographic reproductions. Is there a common denominator that links all of Broadhead's diverse practices? She herself wrote in an article in 1999: 'The narrative, if there is one, is the thread that starts with a

void, a nothing, a searching, leads one on to a discovery process, and runs through to response.'[32] This sums up her own approach to making art. As a viewer we are also able to make a response. First and foremost by allowing ourselves time for a second look in order to grasp both what is there and what is only apparently there, and that taken together can open up a train of thought.

Translated from the Norwegian by John Irons

1 *Off the Shelf*, exhibition at Vitsoe, Munich, 4–14 March 2017.
2 Kimberley Chandler, 'Bibbidi-Bobbidi-Boo', *Art Jewelry Forum*, 26 December 2015, available at https://artjewelryforum.org/bibbidi-bobbidi-boo. Last accessed 14 May 2017.
3 Ibid.
4 Diana Woolf, 'Maker of the Month / Caroline Broadhead', *Ideas in the Making*, November 2009, available at http://www.themaking.org.uk/content/makers/2009/11/caroline_broadhead.html. Last accessed 14 May 2017.
5 Jennifer Harris, 'Introduction', in Jennifer Harris (ed.), *Art Textiles of the World*, Great Britain. Volume 2, Winchester: Telos, 1999, p. 9.
6 E-mail from Caroline Broadhead, dated 4 May 2017.
7 'Interview with Jewellery Artist Caroline Broadhead', *Aesthetica*, available at http://www.aestheticamagazine.com/interview-jewellery-artist-caroline-broadhead/. Last accessed 14 May 2017.
8 Woolf (see note 4).
9 'Interview with Jewellery Artist Caroline Broadhead' (see note 7).
10 John Houston, *Jewellery in Studio. Caroline Broadhead*, London: Bellew Publishing, 1990, p. 7.
11 Peter Dormer and Ralph Turner, *The New Jewelry. Trends + Traditions*, London: Thames and Hudson, 1985.
12 Caroline Broadhead, lecture organised by the Oslo National Academy of the Arts at Kunstnernes Hus, Oslo, 21 April 2017.
13 Cited from Houston (see note 10), p. 44.
14 Ibid., p. 8.
15 Caroline Broadhead, lecture organised by Oslo National Academy of the Arts at Kunstnernes Hus, Oslo, 21 April 2017.
16 Cited from Renee Baert, 'The Dress. Bodies and Boundaries', in Janis Jefferies (ed.), *Reinventing Textiles Vol. 2. Gender and Identity*, Winchester: Telos, 2001, p. 20.
17 Jeremy Theophilus, 'Where Light Passes Through', id., *Caroline Broadhead*, Winchester: Telos, 2001, p. 10.
18 Ibid., pp. 6–9.
19 Chandler (see note 2).
20 Caroline Broadhead, 'Me and my Shadow', *Crafts*, no. 157 (1999), p. 42.
21 Mary Schoeser, 'Bodyscape. Caroline Broadhead', *Crafts*, no. 158 (1999) pp. 58–9.
22 David Whiting, 'Caroline Broadhead. Chiaroscuro', *Crafts*, no. 172 (2001), p. 59.
23 Don DeLillo, *The Names*, New York: Alfred A. Knopf, 1982, p. 158.
24 Susan Sontag, 'The Aesthetics of Silence', *A Susan Sontag Reader*, London: Penguin Books, 1963/1982, pp. 181–204.
25 Steffan Jones-Hughes, 'Storytelling and Mythmaking. Narrative in Contemporary Craft Practice', in Julian Stair (ed.), *The Body Politic. The Role of the Body and Contemporary Craft*, London: Crafts Council, 2000, p. 174.
26 Caroline Broadhead, lecture organised by the Oslo National Academy of the Arts at Kunstnernes Hus, Oslo, 21 April 2017.
27 Ibid.
28 Chandler (see note 2).
29 'Caroline Broadhead and Maria Militsi', Marsden Woo Gallery, available at http://www.marsdenwoo.com/press-broadhead-militsi-main.htm. Last accessed 19 May 2017.
30 Victoria Pomery, *Chiaroscuro*, London: Barrett Marsden Gallery, 2001, p. 12.
31 Caroline Broadhead, lecture organised by the Oslo National Academy of the Arts at Kunstnernes Hus, Oslo, 21 April 2017.
32 Caroline Broadhead, 'Me and my Shadow', *Crafts*, no. 157 (1999), p. 43.

Plates
Words by
Caroline Broadhead

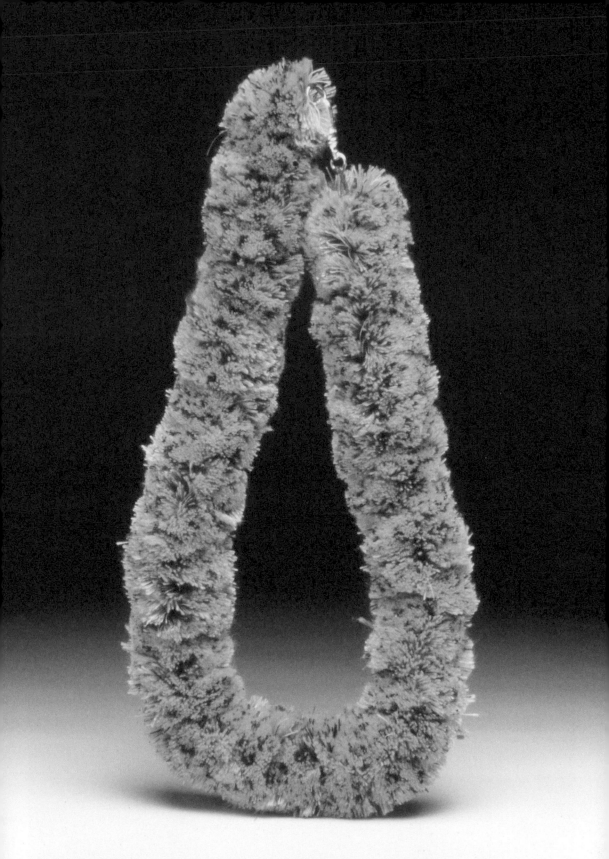

Woolly Necklace 1976

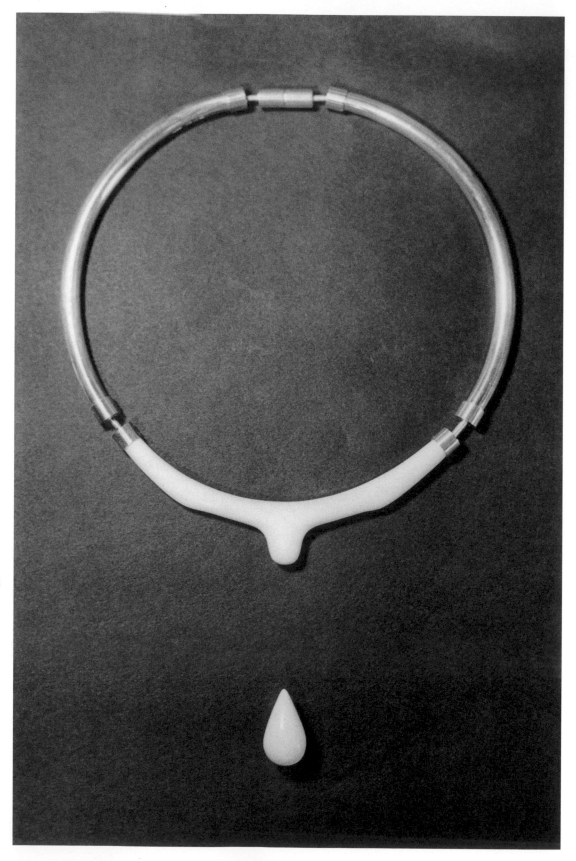

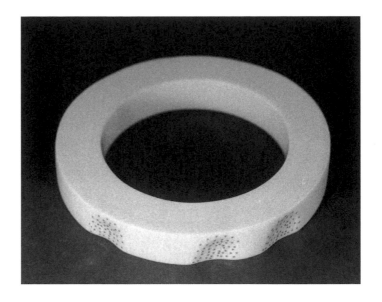

I was interested in making work that had evidence of human contact, what happens in the life of a piece of jewellery. When people and materials interact, there is a possibility of change, a before and after – the knot that had been tied, fingerprints left as a trace of use, brooches dropped or broken, the necklace warmed and melted with the heat of a body. These pieces explored a sense of time, not eternal time but a more contemporary version of our existence – photographic time, a moment recorded as the shutter opens. I saw the body as an active, sensual and equal partner to jewellery.

above *Fingerprint Bracelet* 1973
opposite *Drip Neckace and Brooch* 1973

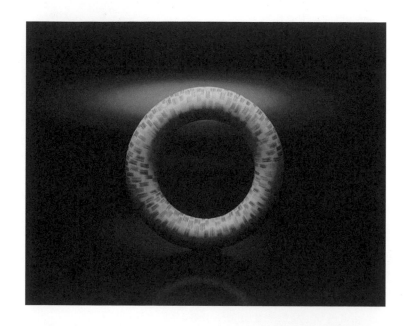

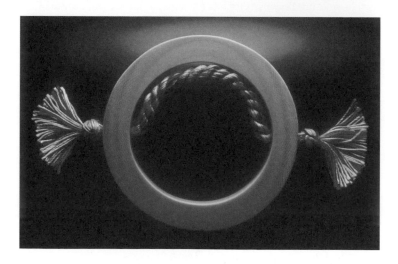

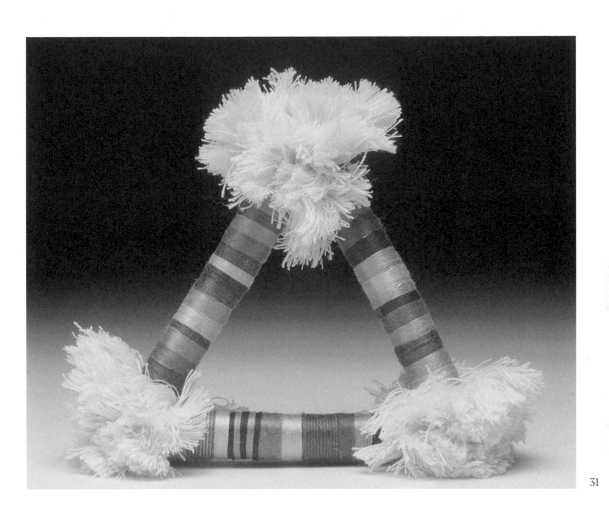

Cotton Bracelet 1977
opposite top *Ivory Bracelet* 1977
opposite bottom *Ivory and Cotton Bracelet* 1977

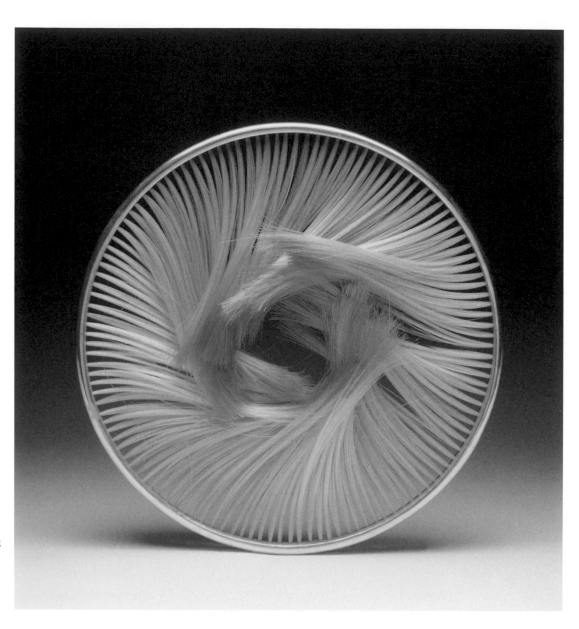

32

Tufted Necklace 1979
opposite above *Tufted Belt* 1979
opposite below *Tufted Earrings* 1979

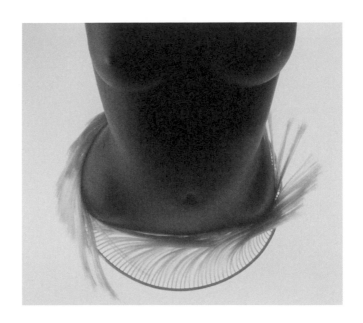

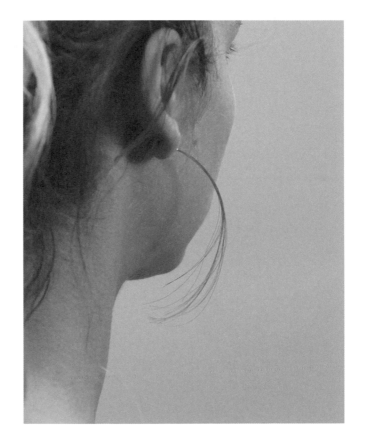

34

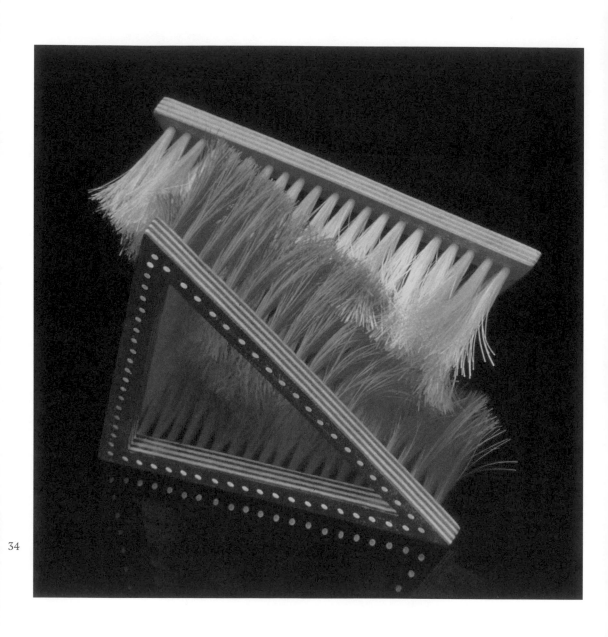

Triangular Tufted Bracelets 1980
opposite ***Skin and Blood*** 1981

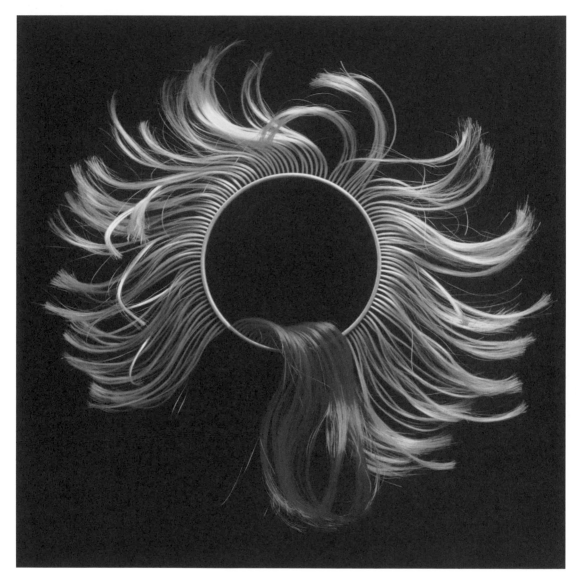

The work that I made on my return from a trip to Africa was about a combination of opposites: flexible and rigid, in contact with the body and held away, geometry and the human form. Above all, these were about the experience of handling and wearing. *Skin and Blood* indicates an awareness of the boundary of the body, the inside and the outside.

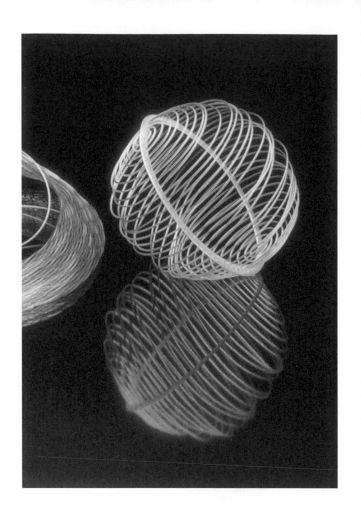

36

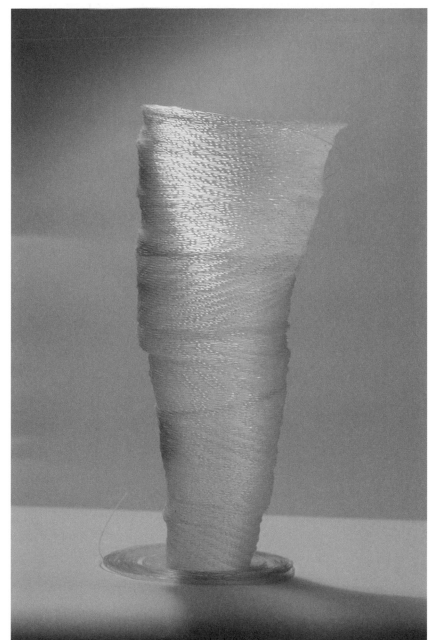

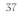

These pieces used one strand of nylon woven round and round to create a very elastic net. After a series of shorter bracelets made in the same way, I wanted to make the piece as large as the body allowed, so by using the body as a measure, the piece extends to where it cannot go any further, stopping at the top of the arm. The intention was for the piece to do two things at once, to have two different characters. Off the body the bracelet looked unlike a piece of jewellery. On the body, it covered the arm like a second skin, translucent and flexible. I was becoming interested in the theatrical and the possible rather than the practical.

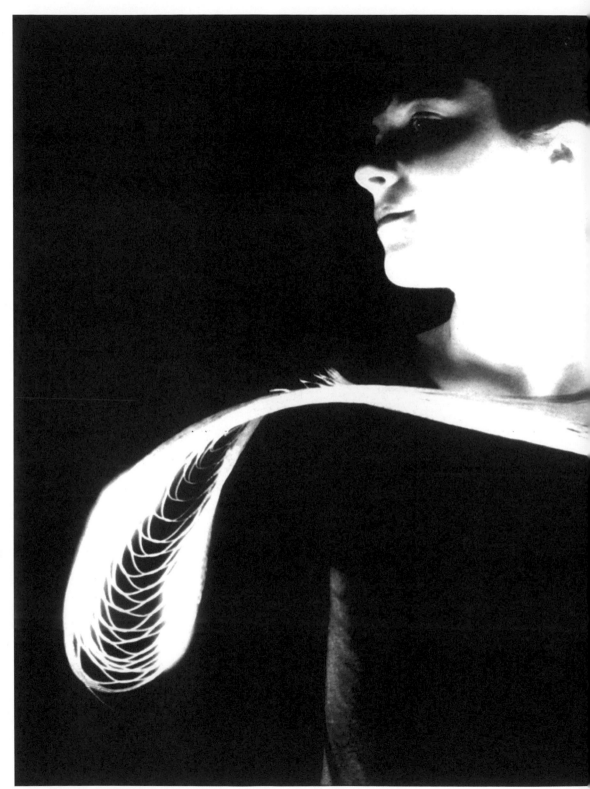

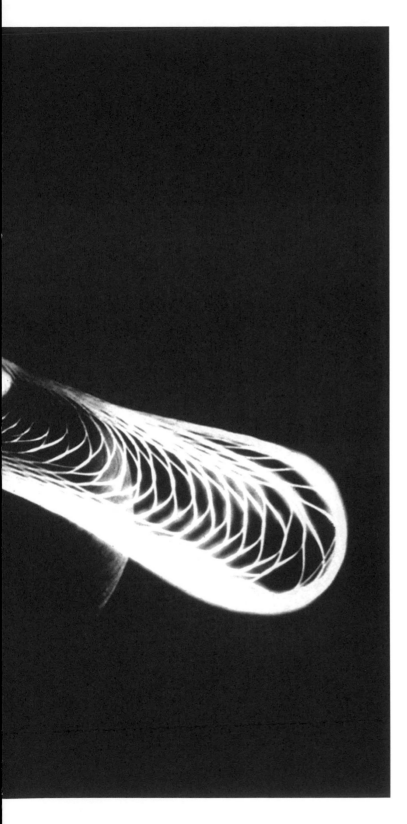

39

Propeller Necklace 1982

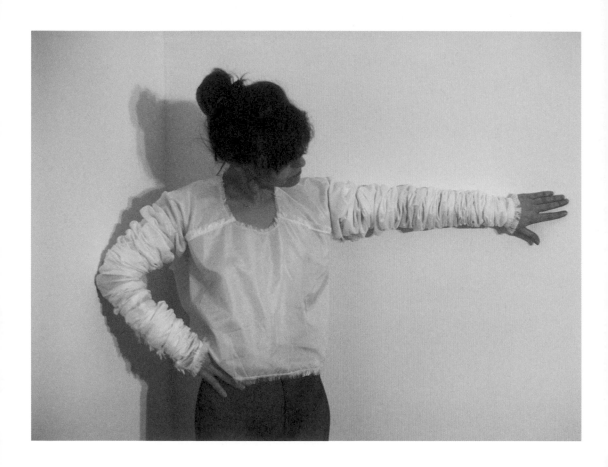

Shirt with Long Sleeves 1982

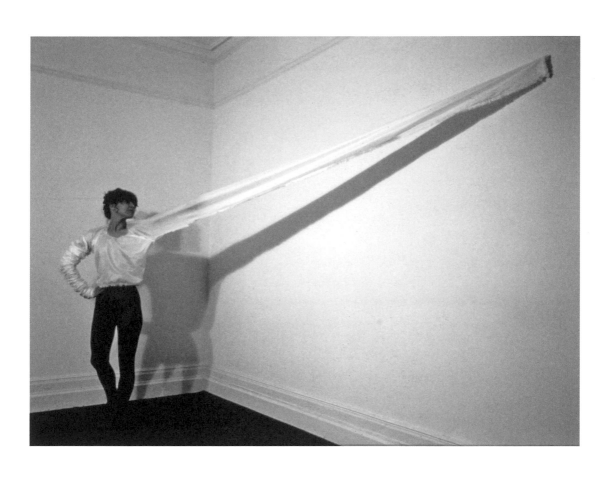

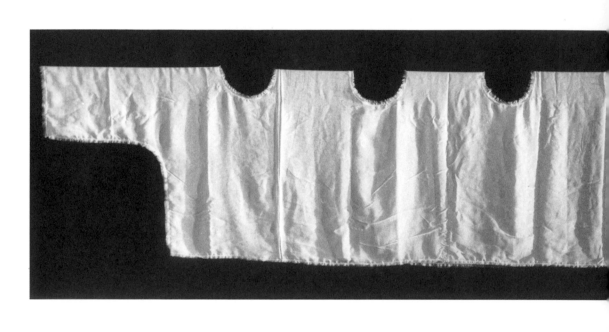

42

Shirt with Seven Necks 1983

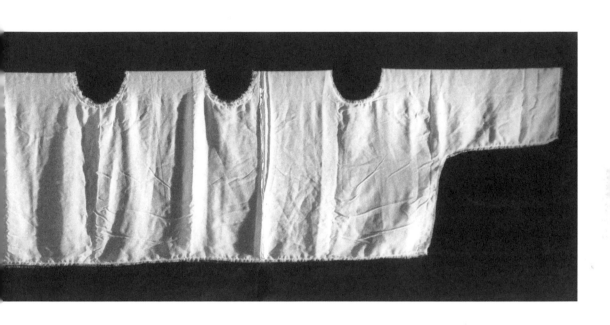

These pieces used the gestures of putting
clothes on and taking them off. While being
worn, they followed the form of the body, but
when not being worn, they extended and
referred to the different, less tangible aspects
of a person, multilayered and more complex.

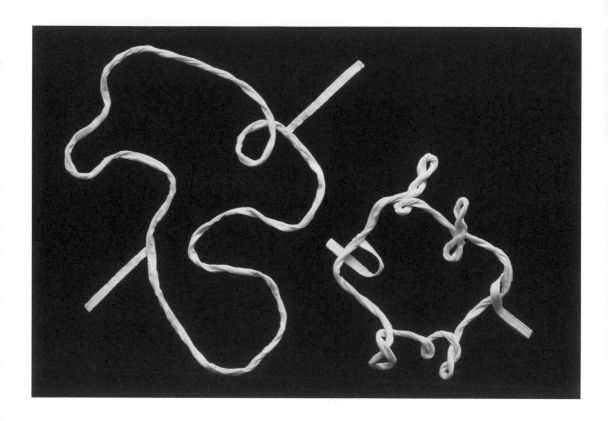

44

Twist to Fit 1983
opposite **18 Cushions** 1984

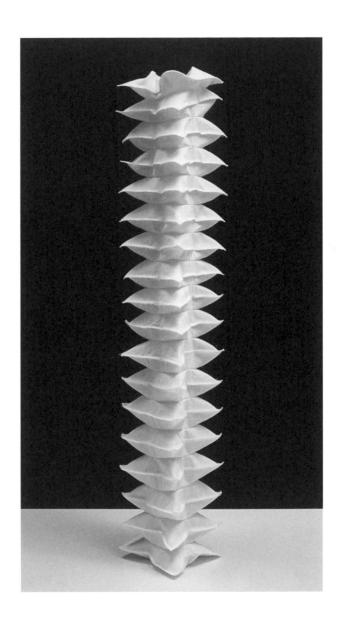

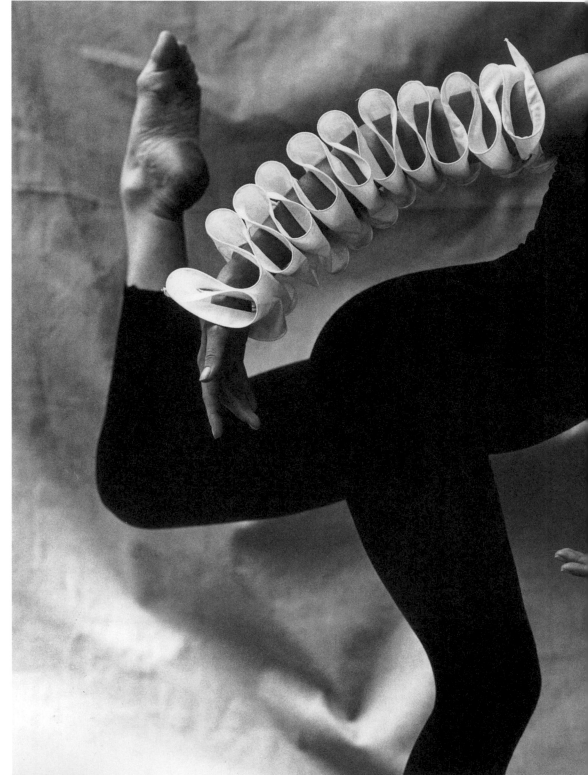

below *18 Cushions and 22 in 1* 1984
left *22 in 1* 1984

I used the idea of expansion and contraction
to give an object two identities, when on
and off the body and when large and small.
These also gave an opportunity to discover
how a piece might fit on the body and give
an experience of putting them on and taking
them off.

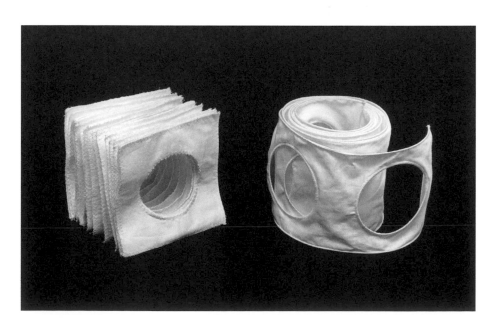

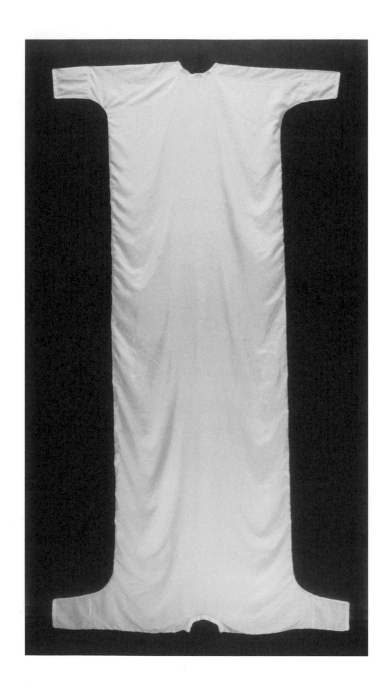

Twinshirt 1984

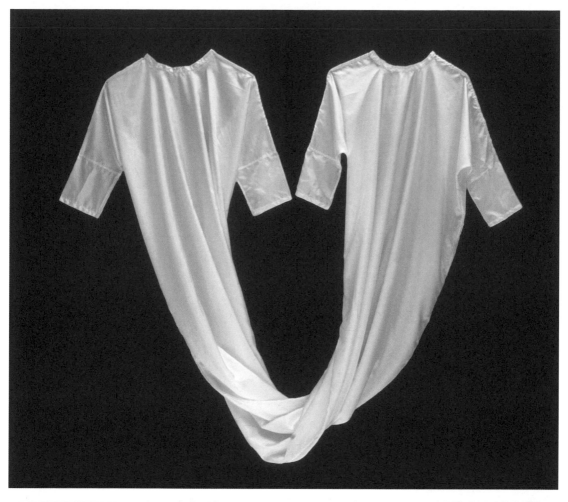

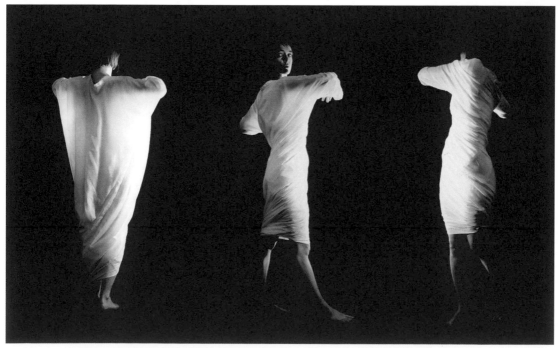

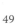

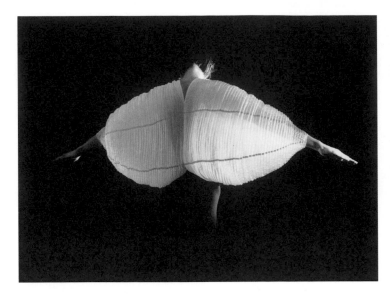

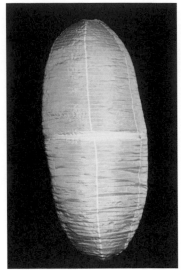

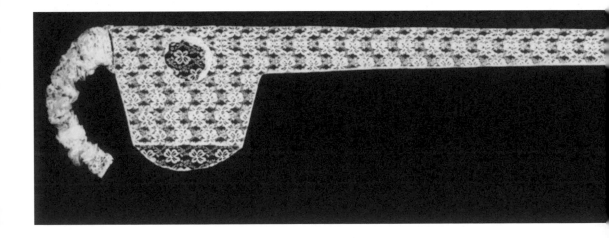

Seven Ages 1986
clockwise from top left:
Seven Ages 1: Cocoon
Seven Ages 1: Cocoon
Seven Ages 3: Uniform
Seven Ages 4: Curling Up
Seven Ages 2: Stretch

Tracing a life through birth to death in seven parts, this piece referred to the "All the World's a Stage" speech in Shakespeare's *As You Like It*. Each was made with a different white fabric to indicate the associated activity or stage. Made over two years, I started out with a self-imposed directive for pieces to be able to be worn, but during this period I realised this was not an essential element for me. As they were being made I was taking the measurements from my body and trying them on, and performance became another way of presenting and exploring them.

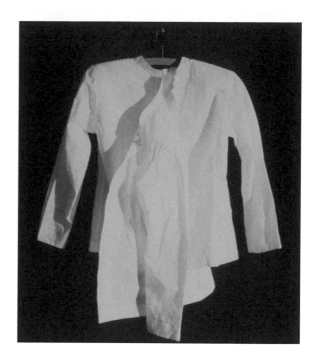

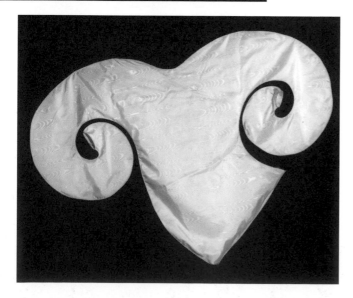

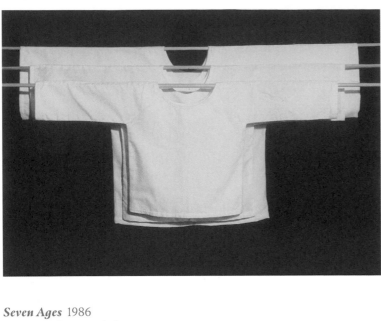

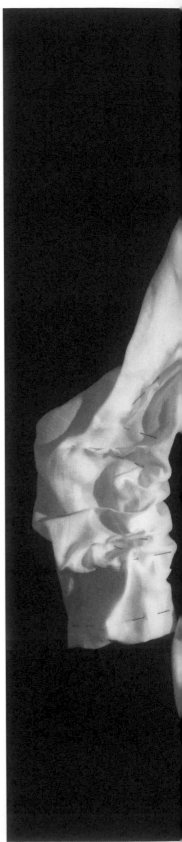

Seven Ages 1986
clockwise from top left:
Seven Ages 5: Carrying People
Seven Ages 6: Crumple
Seven Ages 7: Seam

52

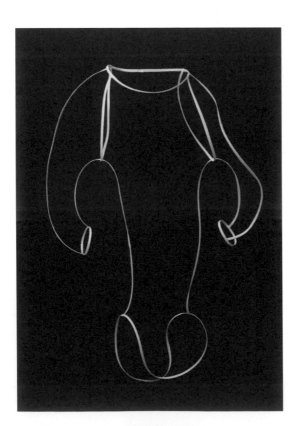

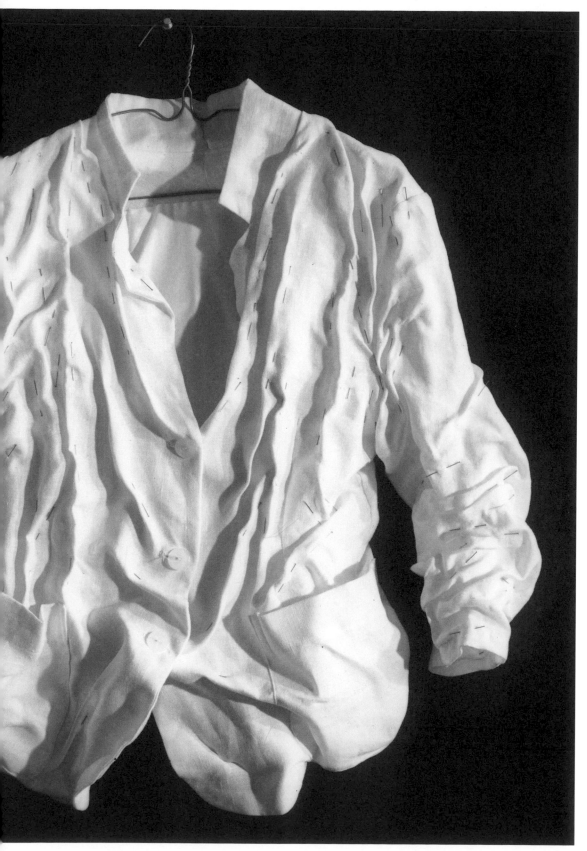

below **Stretch,** 1989
opposite above **Seams** 1990
opposite below **Undercover,**
in collaboration with
Fran Cottell 1990

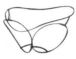

54

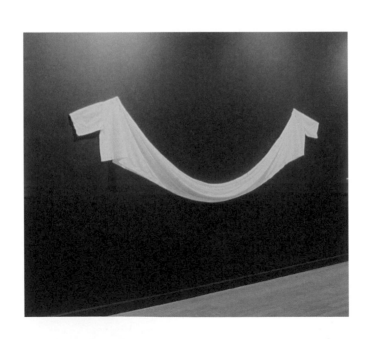

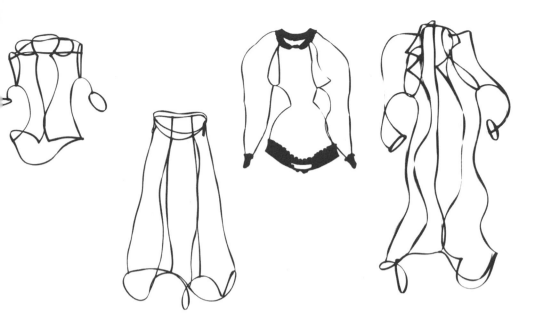

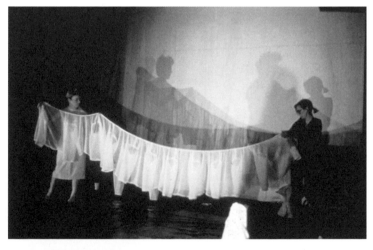

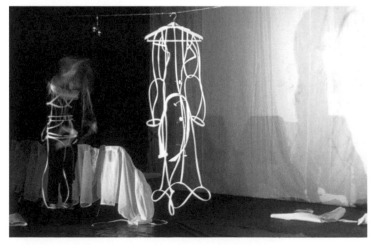

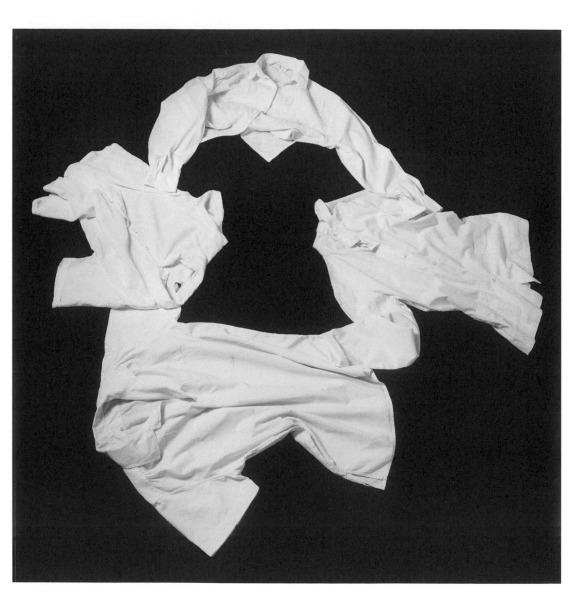

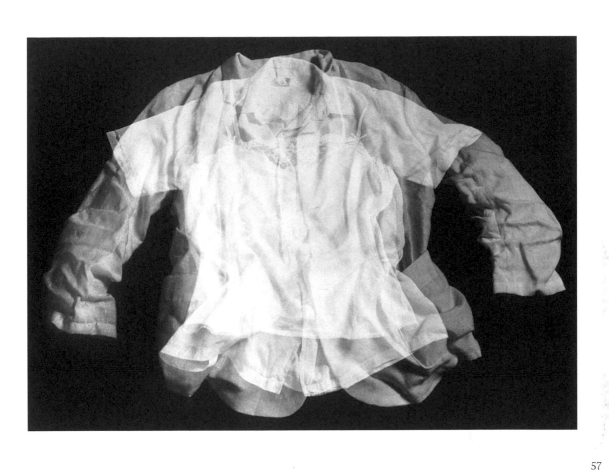

Layers 1990
opposite **Invisible People** 1990

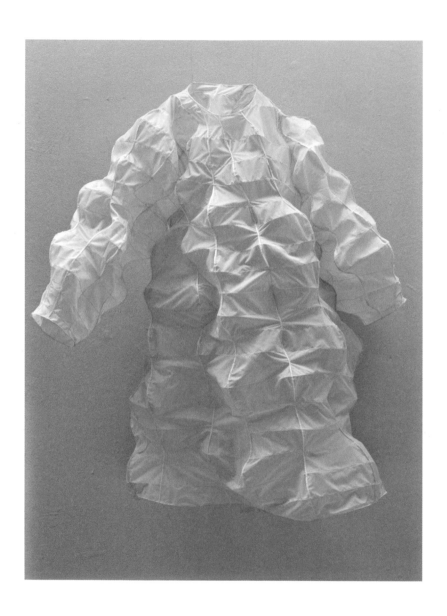

58

Wobbly Dress 1990
opposite **Wobbly Dress II** 1992

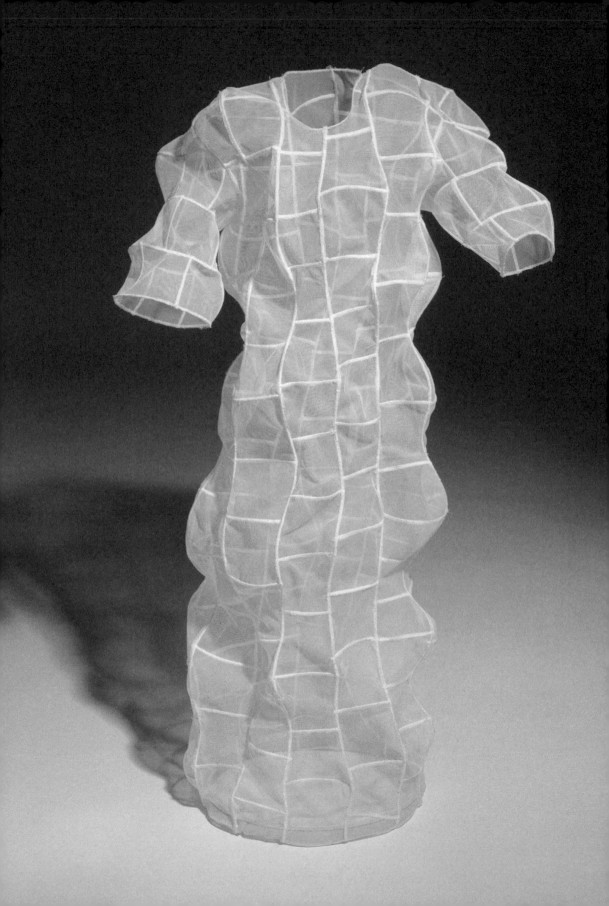

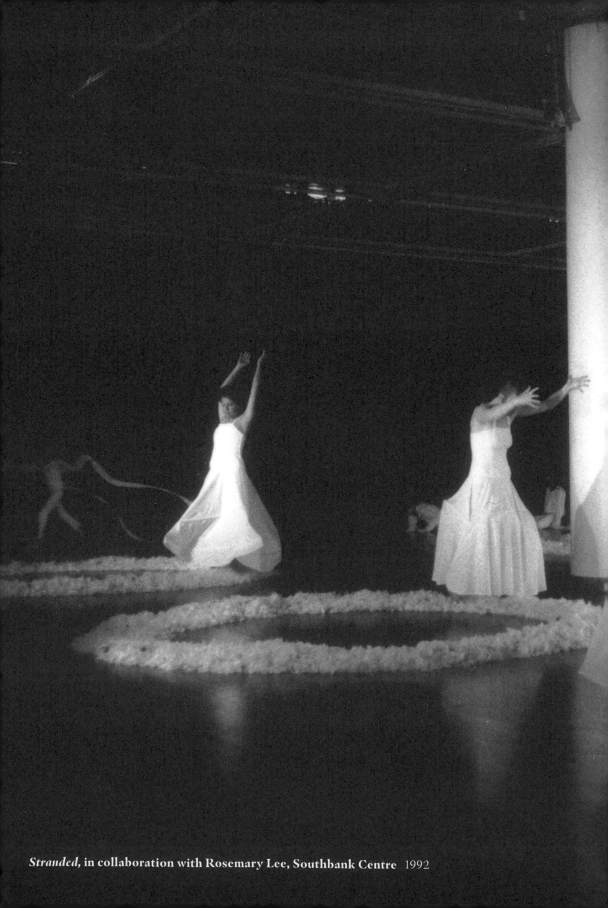

Stranded, in collaboration with Rosemary Lee, Southbank Centre 1992

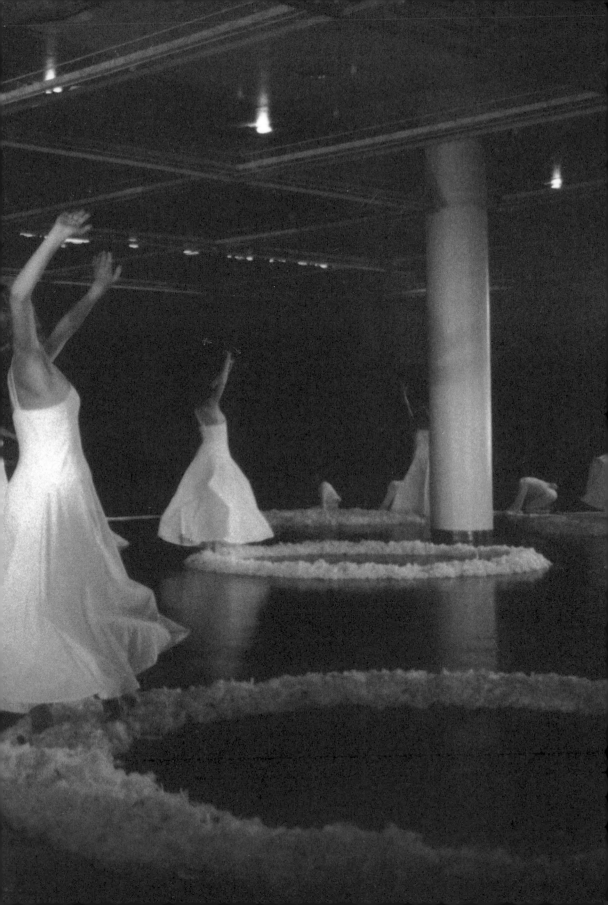

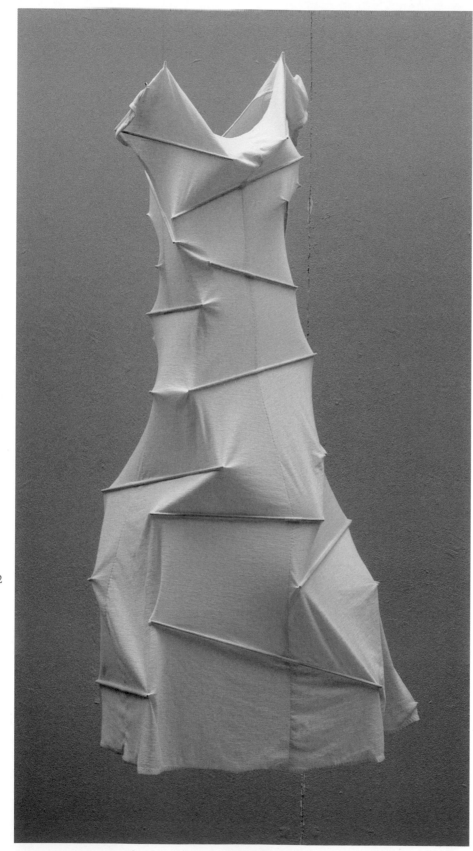

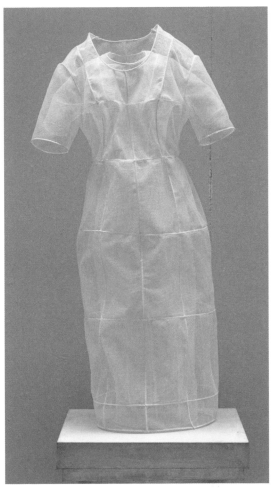

above ***Empty Dress* (detail)** 1993
left ***Double Vision*** 1993
opposite ***Stress*** 1993

I used the dress as a metaphor for a person. It is double sided, inwardly touching the body and outwardly facing the world, becoming the boundary of the self, which is continually being questioned, disrupted and redefined. It is at this edge that tensions, conflicts or contradictions manifest themselves. The dress also signifies the possibility of dressing up, showing a different side of oneself. It can represent the whole person in a way that no other form of garment can. It is a gendered garment, but the conditions I was expressing were not.

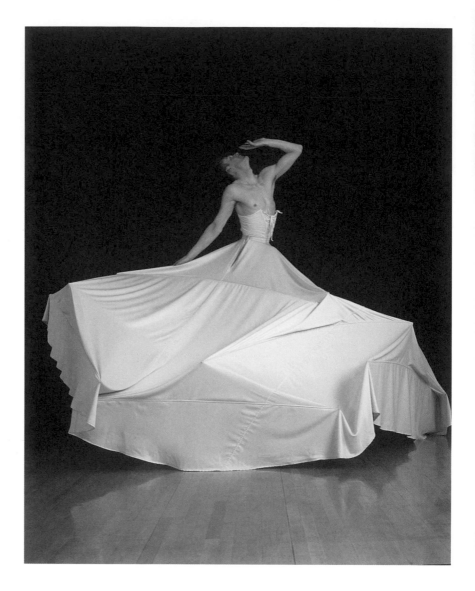

In 1991 I embarked on a series of collaborations with choreographers, and I continued to do this alongside other work. Working with dancers fulfilled the need to work with a living, moving body, giving scope for the use of dynamics of movement, time and atmosphere. *Unlaced Grace* was a dance that drew inspiration from an old corset factory in Banbury, using notions of a changed silhouette and control of the body. The skirts were about 5 metres in diameter, enlarging the spaces the dancers occupied and allowing the smallest of movements to be exaggerated, which continued to move even after the dancers were still. The skirts were hoisted into the air, in the same manner that crinolines were stored in the eighteenth century, and then dropped down onto the dancers who 'caught' them on their bodies.

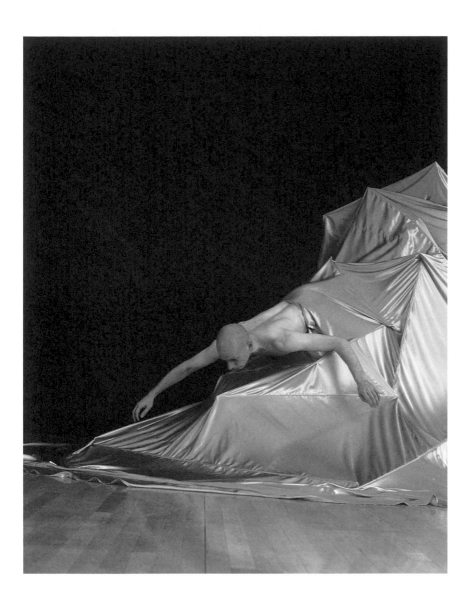

65

Unlaced Grace, in collaboration with Claire Russ 1995

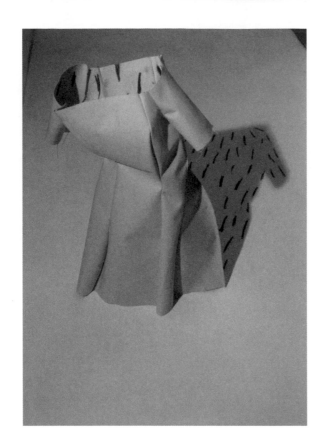

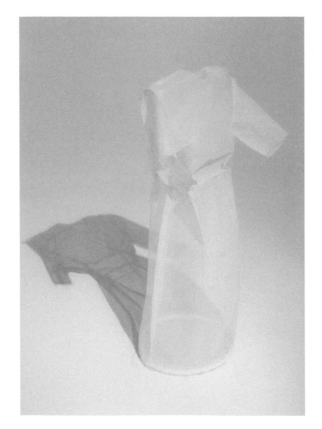

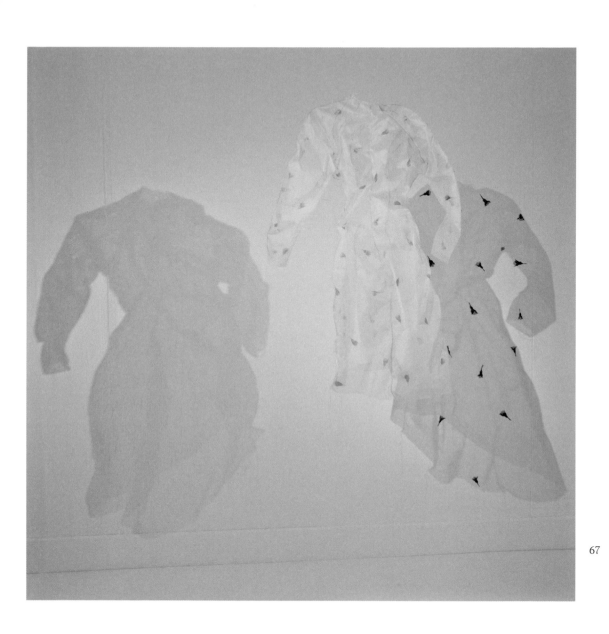

above *Steppenwolf* 1997
opposite top *Over My Shoulder I* 1996
opposite bottom *Over My Shoulder III* 1997

68

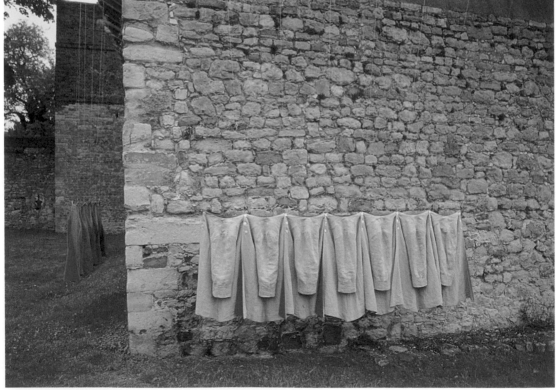

The Waiting Game was a promenade performance in the small garrison of Upnor Castle, on the River Medway, in Kent, which played a part in the Dutch Raid in 1667. The idea of working with coats came from the records of the castle, which recorded incidents of soldiers changing sides to fight for the enemy – in English they are called 'turncoats'. The half-coats, each lined with the other colour, could be worn in several ways – joined together to be buff coloured, turned inside out to be orange – and the movement of the dancers, holding, turning, or whipping of limbs, revealed the colour underneath. Eventually the double layers of the half-coats were pulled out to be half buff and half orange, and all the dancers wore this 'uniform'.

The white dress (p. 17) was inspired by the idea of a female presence which had not really been recorded in history, women who had to work there quietly, tethered to the building. The audience came down the steps into the room and had to tread on the dancer's dress, which allowed her to move in a particular way, to pull away. The audience acted as both an anchor and invader and as such became an integral part of the dance. The idea of trespassing on the dancer's dress was to offer a personally felt experience, which could lead to a recognition about how much larger and more dangerous conflicts arise.

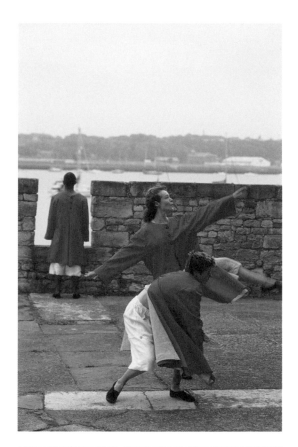

Waiting Game, in collaboration with Angela Woodhouse, Upnor Castle, Kent 1997

70

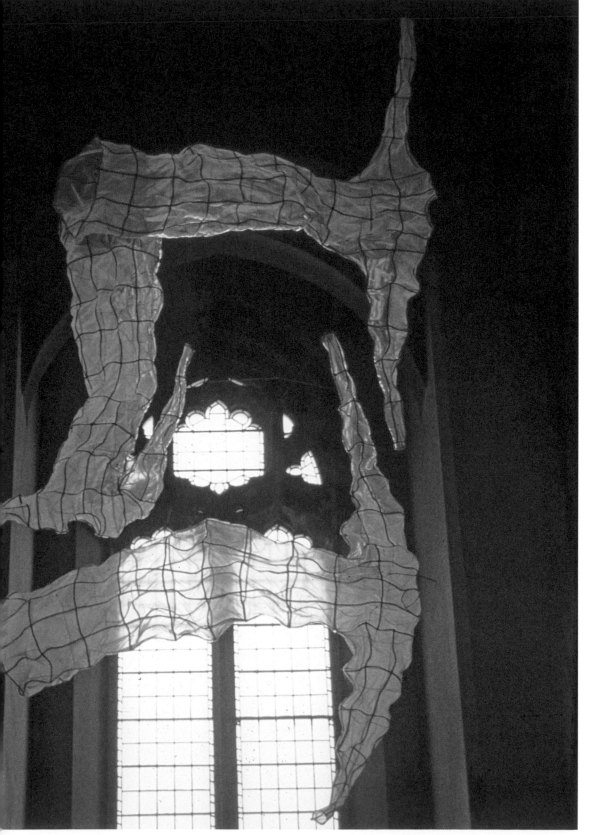

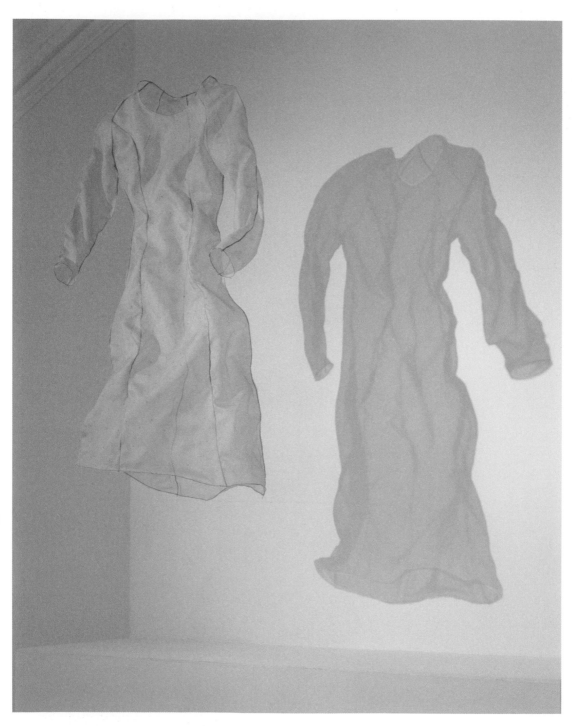

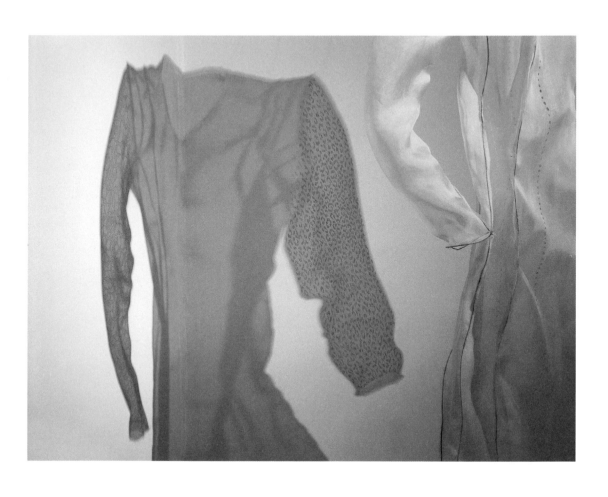

Ready to Tear (detail) 1998
opposite *Dress with Holes* 1998

74

Danger Shadows 1998

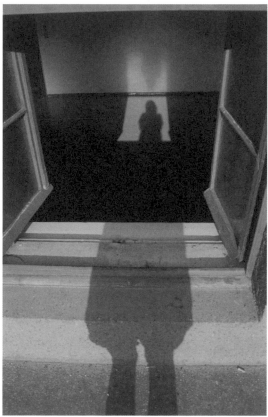

76

Dress with Black Holes 1999
opposite ***Tunnel Dress*** 1999

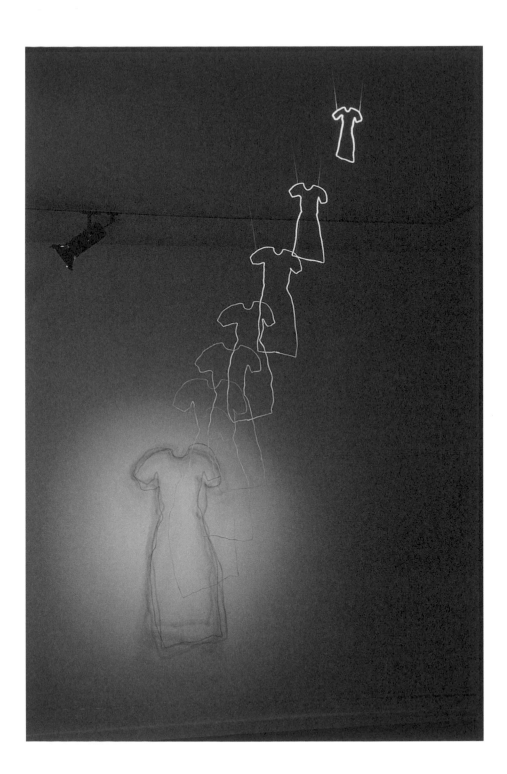

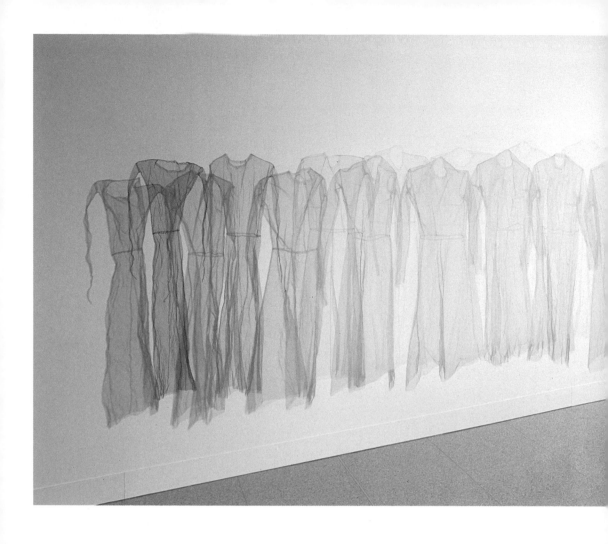

78

in-crease-de-crease 1999
opposite *Feint Outline, Textures of Memory, Angel Row Gallery, Nottingham* 1999

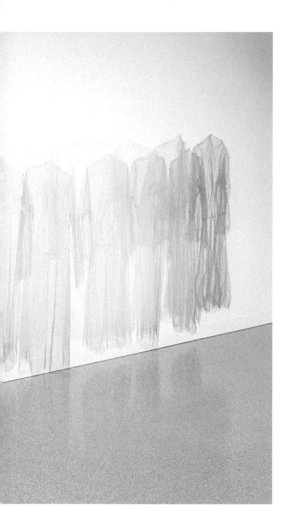

in-crease-de-crease is a line of dresses made of fine tulle. The central one is white and follows the proportions of a person, and when set against a white wall, it becomes ill-defined and confused with its own shadow, while the outer ones get progressively larger or smaller on either side and gradually increase in colour to blue and red. The fabric is made up of more space than substance, so the shadow has a great amount of detail in it, which makes it hard to know whether you are seeing the dress or its shadow. The extremes become strange distortions of the middle one. I was thinking of the way we perceive ourselves to be the centre of the space we occupy – the physical space of our bodies – and also of the invisible territory outside of our bodies that we claim to be ours. The borderline between the self and the non-self is ever shifting and adaptive to different situations, made up of layers.

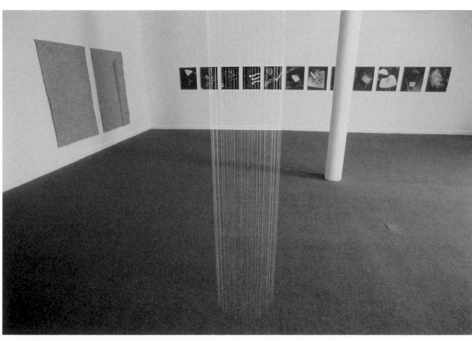

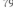

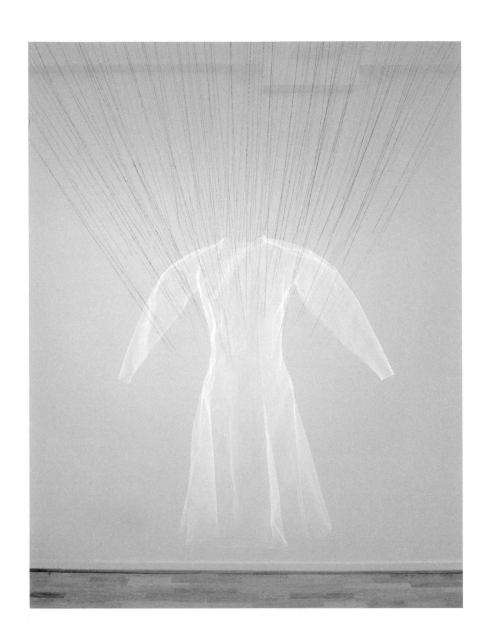

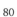

Suspend 2001
opposite *Spot* 2001

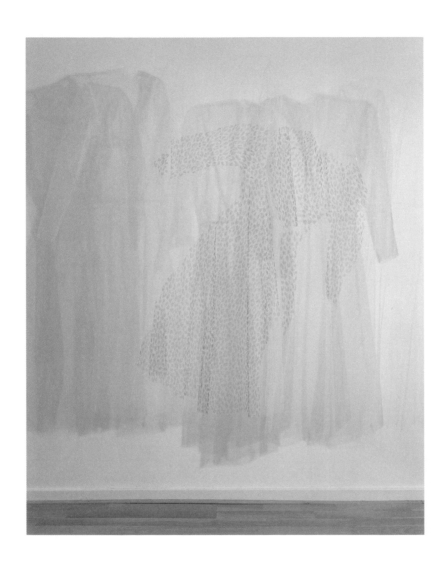

82

Beside Myself (detail) 1999
opposite top *Overlap* 2001
opposite bottom *Eclipse* 2001

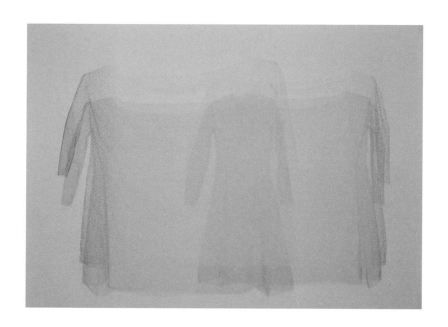

The Uncanny Room exhibition explored notions of the *unheimlich*, the use of the domestic or homeliness to convey feelings of otherness, and works were installed into Pitzhanger Manor, the nineteenth-century country house of Sir John Soane, architect of the Bank of England. Sir John Soane spent many years travelling, collecting classical antiquities from Europe on his Grand Tour, and this eclectic collection is held in his Lincoln's Inn house in central London. My response was to duplicate this process of displacement, bringing foreign goods to a new place. For *Drift*, I appliquéd the pattern from the ceiling in the drawing room upstairs onto fine, translucent silk and installed it to become a ghost ceiling in the vestibule.

Drift, The Uncanny Room, Pitzhanger Manor, London 2002

Away was an installation of eighty dresses which hung in a line that followed the edge of the room. This created a narrow corridor between the dresses and the walls. It gave a choice about whether you moved the dresses to enter the space or whether you walked around at the edge. The movement of walking close by the dresses caused an air current that made the dresses wave around.

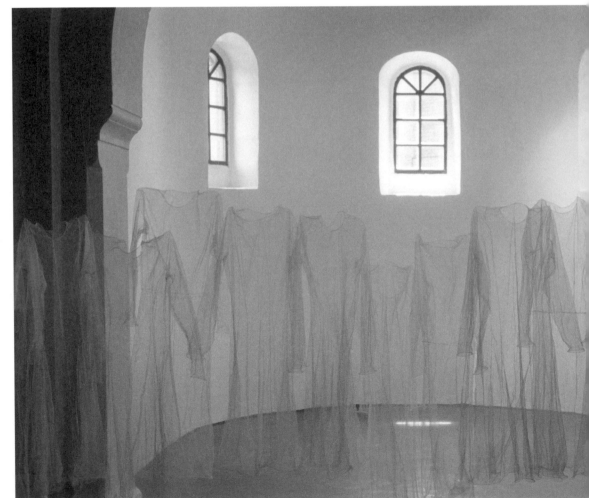

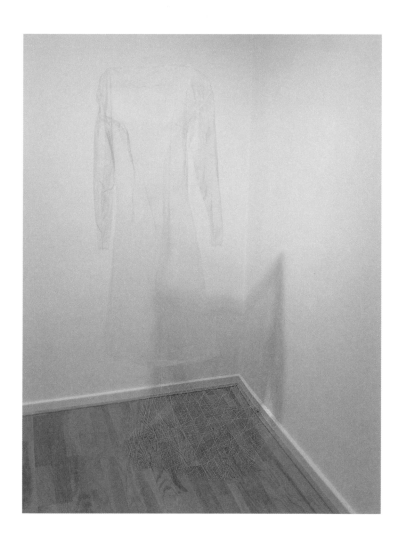

above *Cornered* 2001
left *Away,* **Mission Gallery, Swansea** 2003

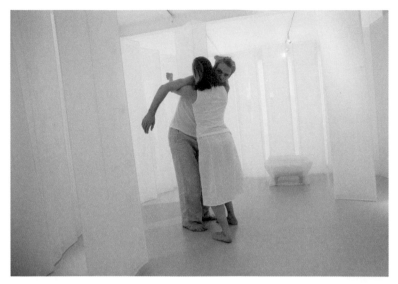

Court, in collaboration with
Angela Woodhouse 2003

A duet for an audience of three, *Court* toured to galleries and theatres. The two dancers gave a detailed performance in an enclosed space, formed by pillars of translucent textile. This allowed for subtle and intimate confrontations, initially as a one-on-one encounter and then as a gathering of performers and audience in the central space.

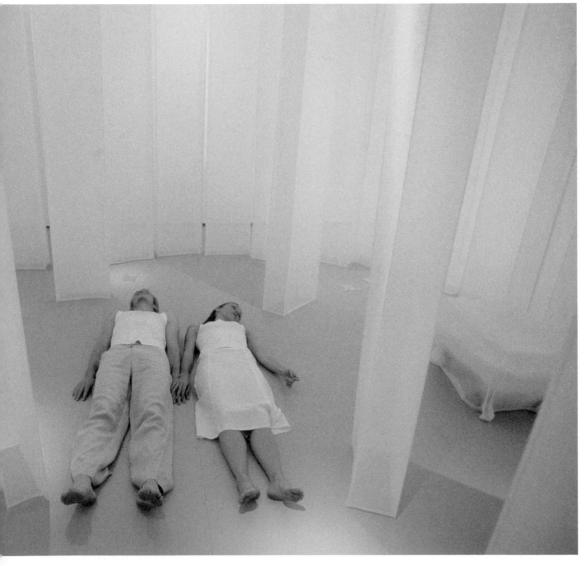

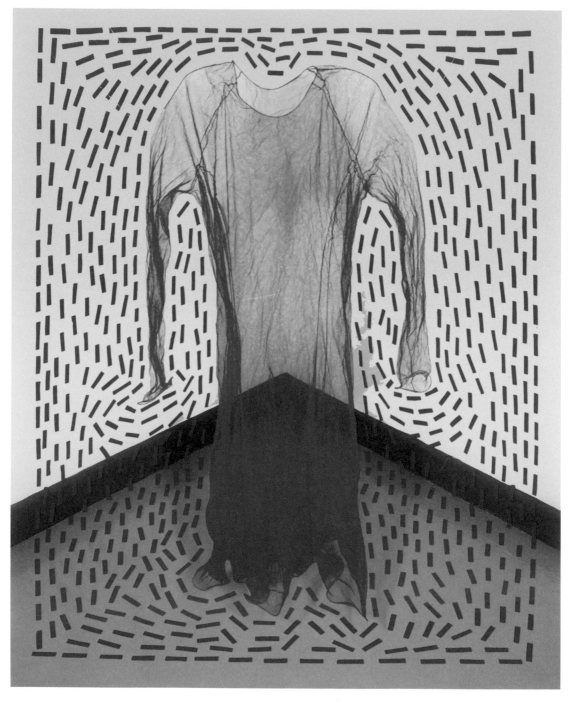

Red Dress Space I 2004

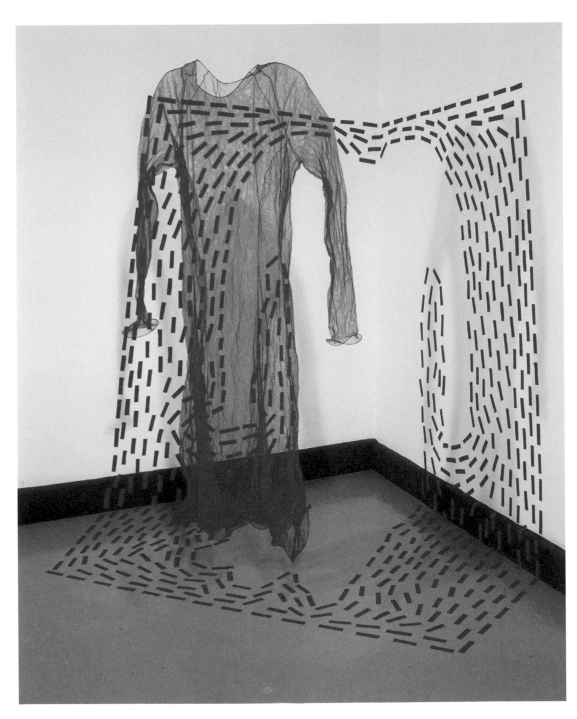

I was exploring a privileged point of view. From most positions
the view is a three-dimensional one with a sense of space,
and the view from a specific position offers the illusion of the
lines suddenly forming a flattened frame around the dress. The
piece is an integration of these views, a hope of finding order
within disorder.

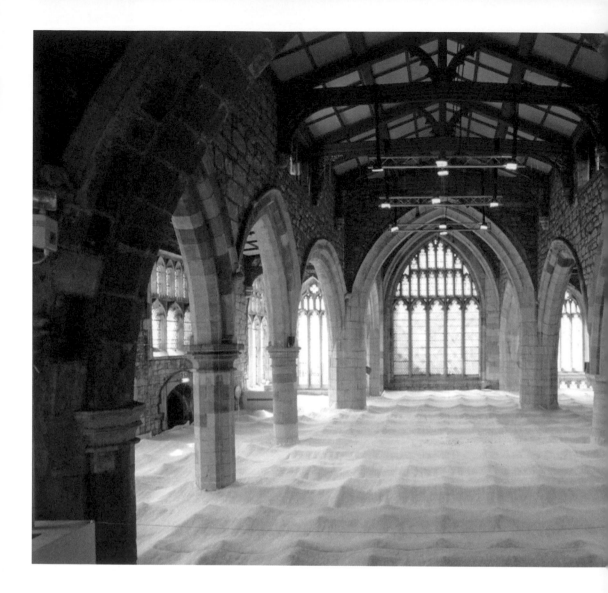

92 York St Mary's is no longer a place of worship, but architecturally it reads as one. Initially I looked at what a church meant: the early church referred to a group of worshippers and only later did it come to mean a building where worship took place. The ceiling was therefore the last physical difference between the two meanings. Then I looked at the architectural features that contribute to the quiet, awe-inspiring and meditative atmosphere of a church. The high ceilings imply a limitless sky and inspire a heavenward gaze. The light passing through the windows also has strong meaning. I also looked at what you expect of a place of worship: it is a place to reflect and a place to catch your breath.

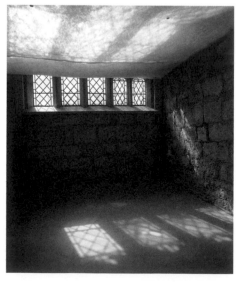

Breathing Space 2005

The building had a sense of history, prompted the act of looking up and down, embodied metaphors of light and dark; it was a place to remember the dead. The earliest part of the building was eleventh century, and then there had been various additions, so the architectural style was mixed, and not always sympathetically. There were different levels: headstones set in the floor, pillars of stone, leaded glass windows and a 1970s ceiling. My instinct was to somehow get rid of it; it was an eyesore.

Suspended fabric brought the ceiling down from 10 metres high to approximately 1.8 metres high off the ground, using a material used for padding quilts. The choice of fabric was to act as a contrast to the cold stone, to give the space a sense of warmth. At each point it was suspended I stitched a lead button, so the effect was of an upside quilt. It divided the space of the building, defining and separating two distinct areas into higher and lower, one accessible, the other not, a space that reflected a belief structure. The fabric caught and filtered the daylight from the windows. The whole of the space was covered, and having a low ceiling meant that at some points you were almost touching it, which gave an oppressive feeling. As it was translucent and there was light above, you were aware of a space beyond but couldn't see it. The main entrance led you to the ground floor, but you could re-enter the building and come in at a higher level, where you could look down on the space, which gave a different view.

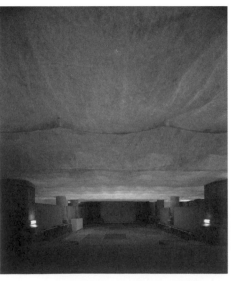

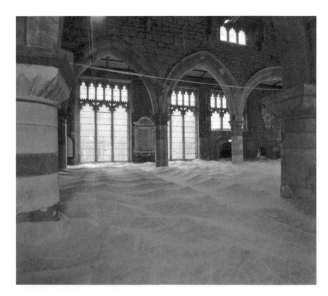

Overhead and Underfoot,
Unbound, **Turnpike Gallery,**
Leigh 2007

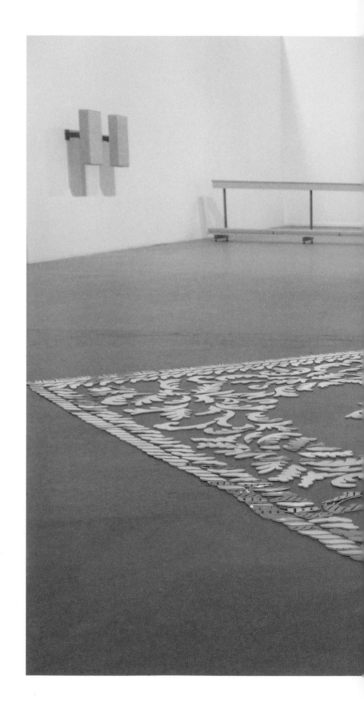

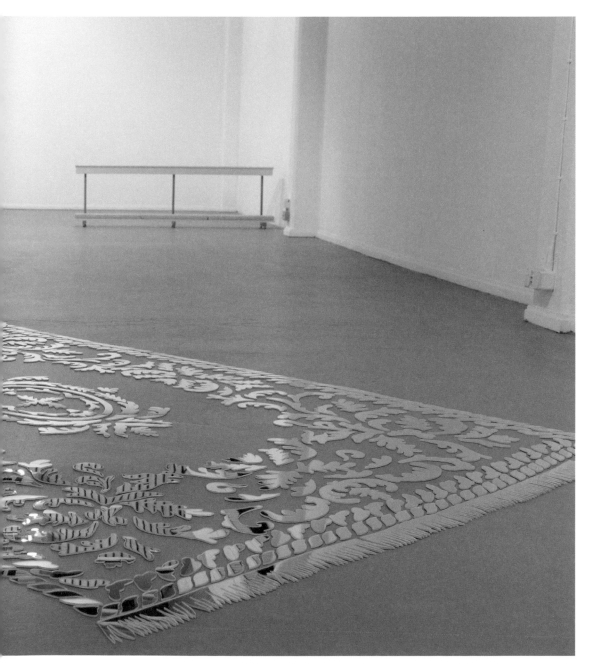

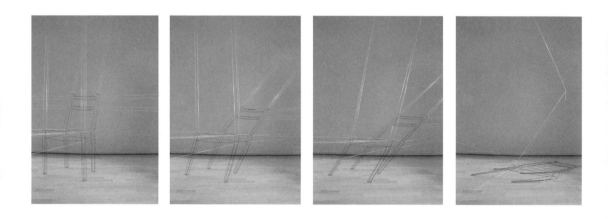

96

Shadow Fall 2007
opposite ***Mirror Window*** 2009

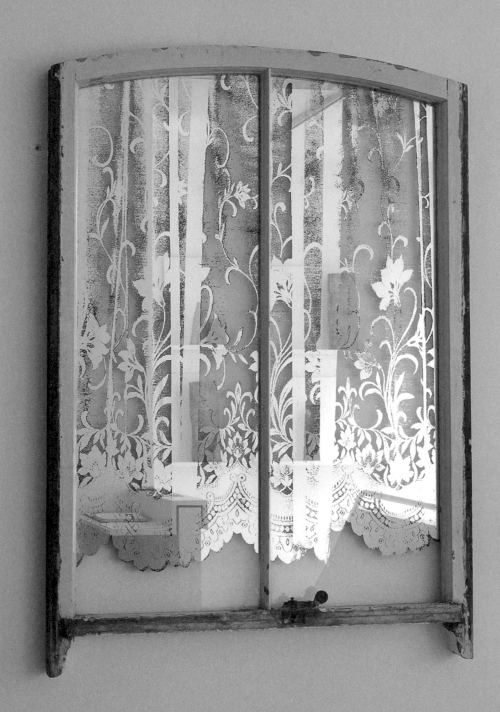

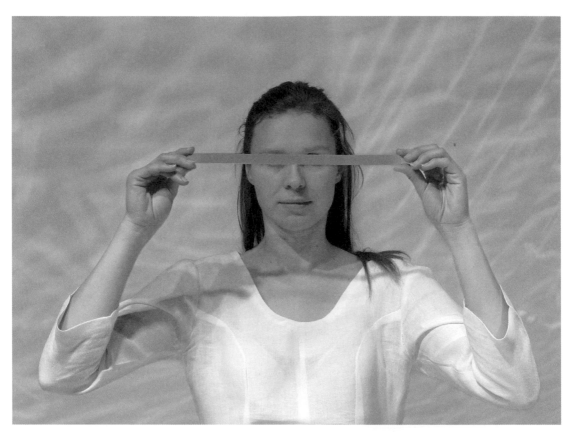

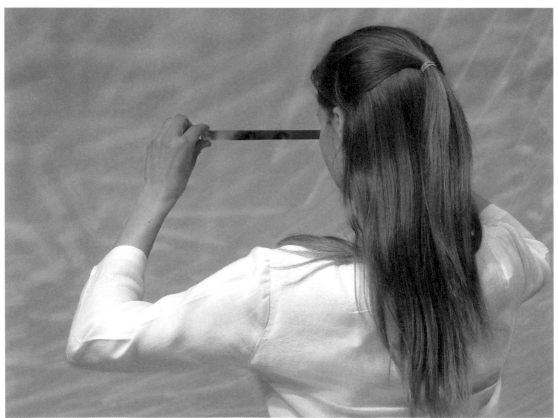

this page and overleaf
Sighted, **in collaboration with**
Angela Woodhouse 2009

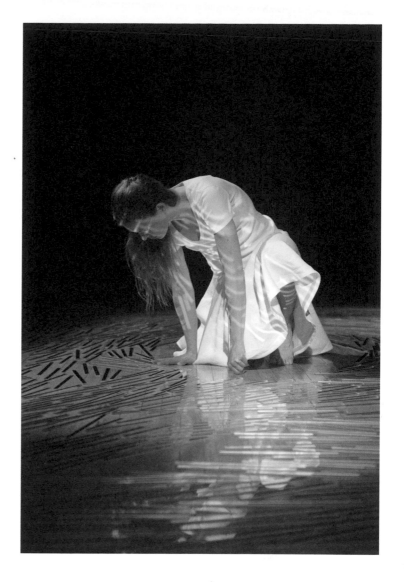

The piece was a double solo installation concerned with
spectacle, with looking and seeing, with the capacity to
see and the urge to be looked at. Two separate spaces, one
light and one in darkness, were performed simultaneously
for two different audiences. The dark space was lit only by a
small torch handled by the dancer, revealing to the audience
elements of herself and the space. In the light space, the
solo dancer performed for extended periods of 'blindness',
only occasionally opening her eyes to look at the viewers.
The audience of about twenty people was free to stand or sit
anywhere, and they could choose to look directly at the dancer
or audience members or indirectly through the mirrors. They
in turn could find themselves being the object of another's
gaze. The chance to look into the eyes of a stranger in a formal
setting is both disconcerting and appealing. This happened in
close proximity and also when the dancer picked up a mirror
and slowly turned around catching glimpses of the audience
and allowing a view of her eyes.

99

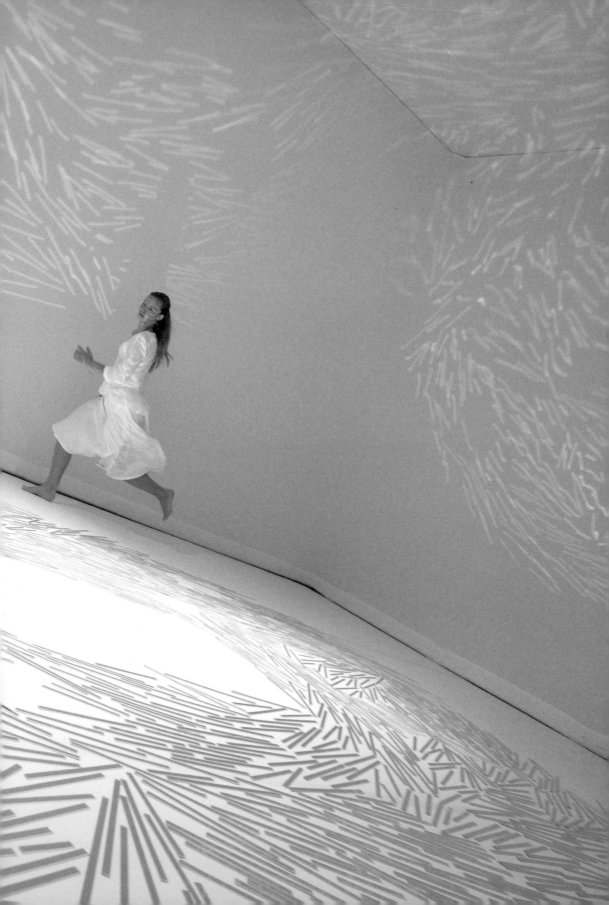

this page and overleaf
Between, **in collaboration with**
Angela Woodhouse 2010

Viewers shared a common space and could move fluidly between the roles of both witness and participant, making choices about their level of intimacy with the performers and so navigating their own forming of the work. There was an intentional ambiguity, the experience indicating a sense of expectation and spectacle, and it was this sense of 'between states' where the performance lay. The purpose was to create a heightened experience for audience and performers through economy of means. Simple but striking visual elements were used, such as the spectacle of gold leaf on the body, pearls breaking and falling to the floor or the sound of reflective coats moving. These aural and visual elements were sparse but significant to intensify the sensitised atmosphere, leaving traces both in the space and on the bodies of others.

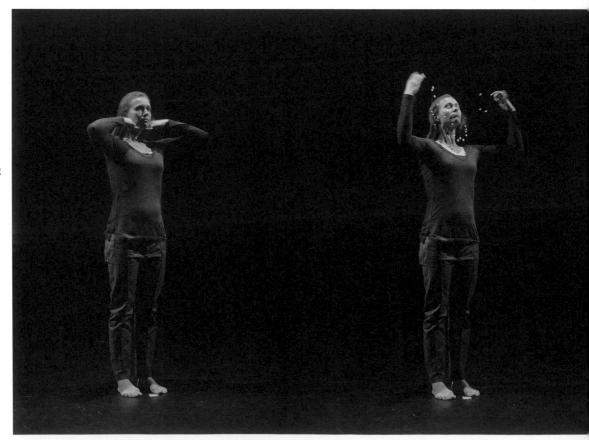

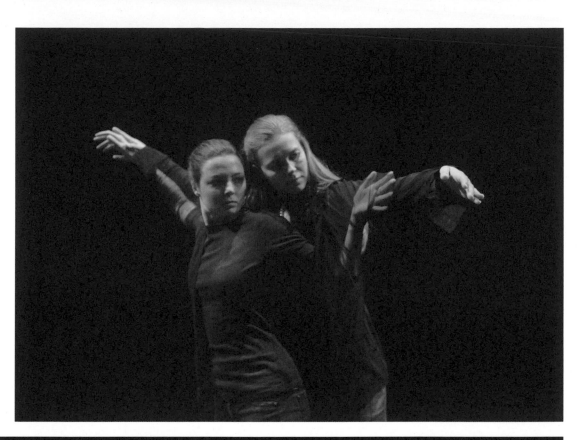

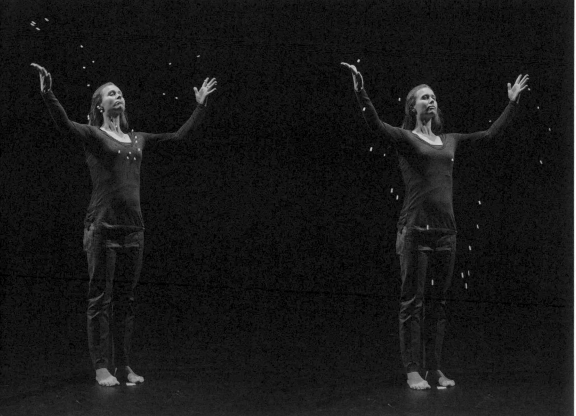

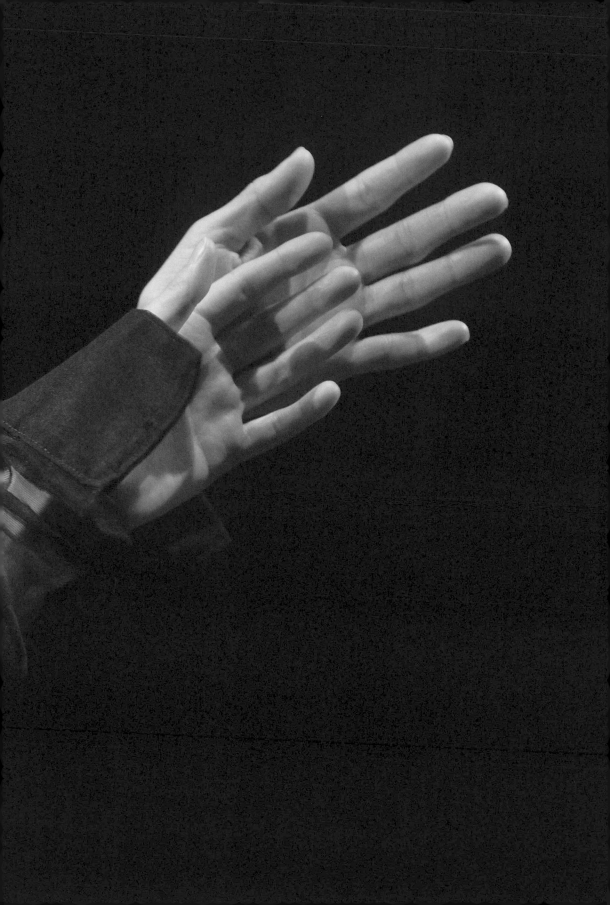

Angela Woodhouse and I were awarded a Maven Commission to create a dance which engaged with the themes in Jenny Holzer's work shown as part of the Tate Gallery's Artist Rooms. Pieces such as *Purpose (Yellow, White)* re-presented documents, obtained by Holzer under the Freedom of Information Act, showing censored elements obliterated with black ink. The LED piece, *Blue, Purple, Tilt*, with its visual assault of bright, flashing messages, became a significant element in the experience of the piece.

Censor(ed) took its central theme of being able to see or not being able to see and was performed in the gallery. The audience of thirty were split on both sides of the performer and framed within black taped rectangles on the floor. *Censor(ed)* referenced the desire to know what is hidden from view and under what circumstances, and played with notions of secrecy and control. We invoked an image, widely used in the media, where the eyes of an assailant or a victim are blocked out with a black rectangle to protect their identity. The intimacy of the dancer being in close proximity to the audience appeared to make her available, 'one of us', but with her eyes blocked out, the audience was 'shut out', and this was intended to create some discomfort. She was dressed in a formal, black, transparent garment, suggesting both authority and vulnerability, and this was compounded by the subtle gestural language that could indicate her to be perpetrator, arbitrator or victim.

106

Censor(ed), in collaboration with Angela Woodhouse, The Lightbox, Woking 2010

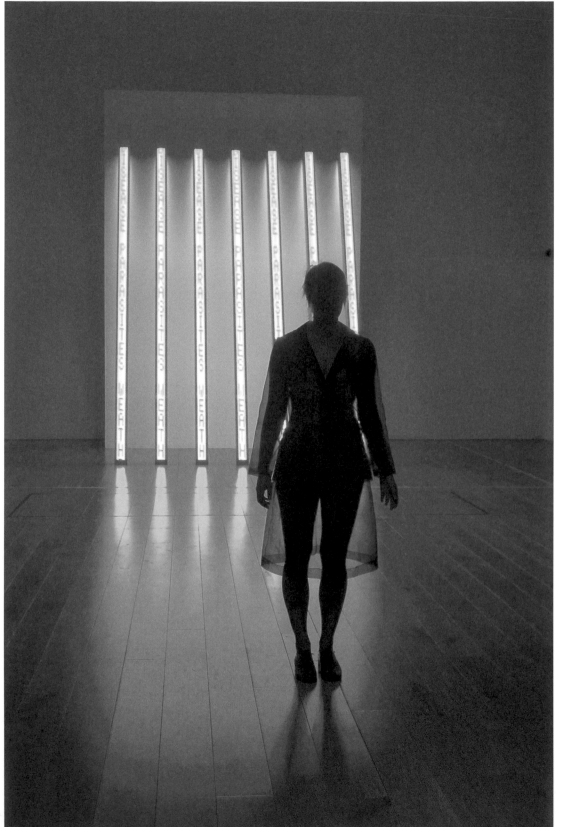

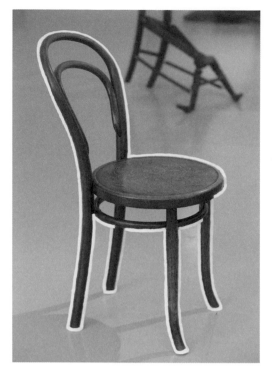

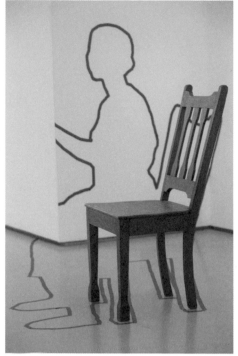

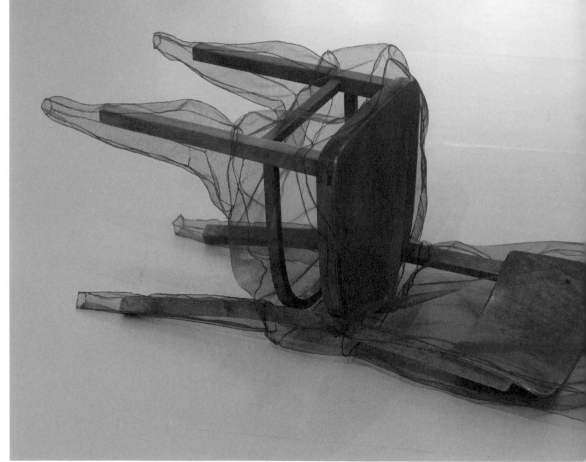

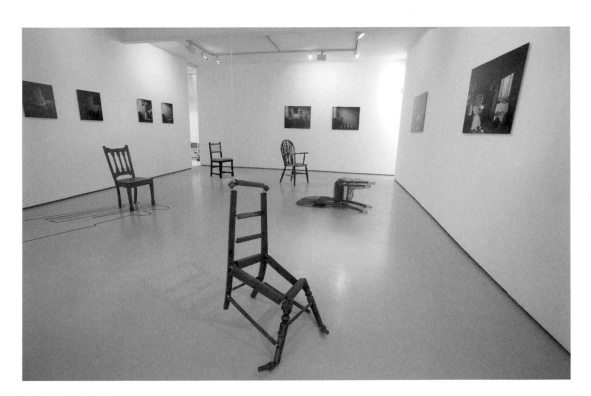

Taking the Chair was a collaborative project with Maisie Broadhead, where we each produced work independently, but we discussed everything in detail together. Our starting points were paintings where an empty chair played an important role. The chairs indicated an expected or departed presence, a sense of disorder, as when overturned in Hogarth's *Marriage A-la-Mode* series, or of status, as in the child's throne in Velázquez's *Prince Felipe*. I interpreted the chairs in three dimensions, and Maisie photographed them in a reworked and contemporary setting.

109

clockwise from above
Taking the Chair, Marsden Woo Gallery, London 2011
Thrown Down 2011
Defining Line 2011
Chairperson 2011

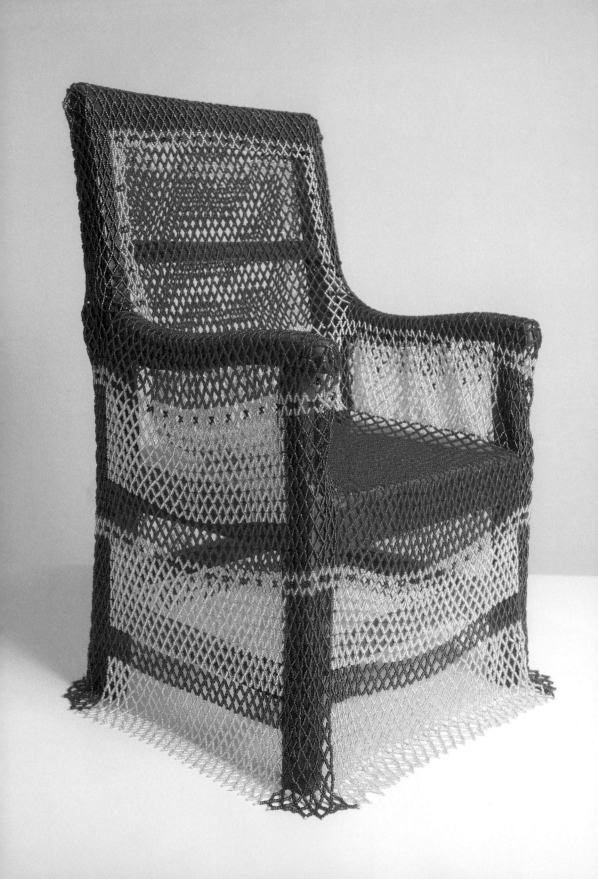

clockwise from opposite
Dressed Up 2011
Light Interrupted 2011
Sitting Room 2011
all shown in *Taking the Chair,*
Marsden Woo Gallery, London 2011

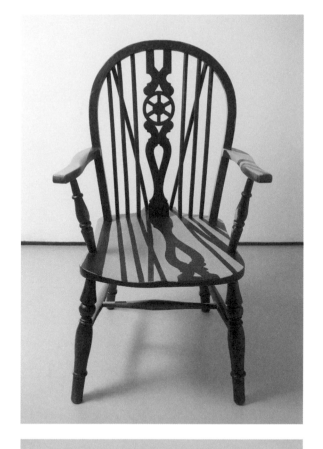

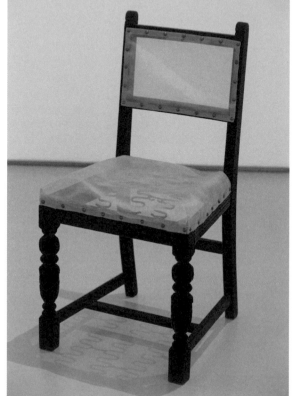

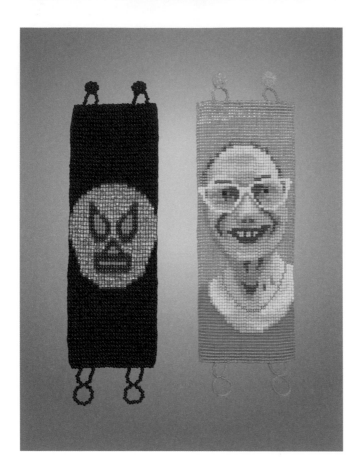

I had bought a beaded bracelet as a souvenir of a lucha
libre fight in Mexico, which cost less than ten pounds.
I was among the jewellers attending the "Walking the
Grey Area" conference in Mexico in 2010 who were
affected by the Icelandic volcano eruption that stopped
flights for several days. Being stranded made me feel
distinctly more foreign and very English. Invited to make
a response to this experience for the *Under That Cloud*
exhibition, I placed my image within a bracelet that
represented a Mexican craft tradition but also has a
flavour of English needlepoint embroidery. The cost of
mine reflected the hours it took to source the materials,
work out how to do it and translate the image to colour
units, and these hours were charged at the minimum
wage for over twenty-ones, which was £5.93 per hour.

Stuck in Mexico 2011
opposite *Shaved Chair* 2013
overleaf *Still Life, Stool* (detail) 2015

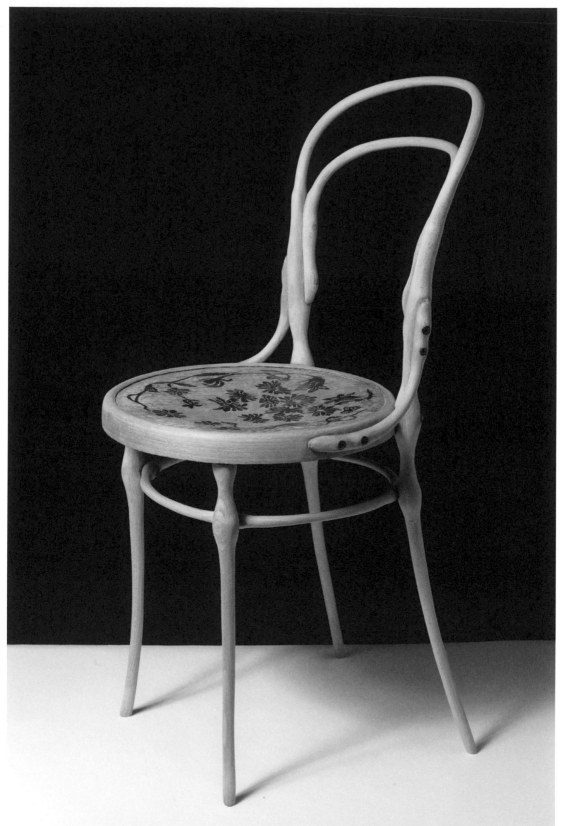

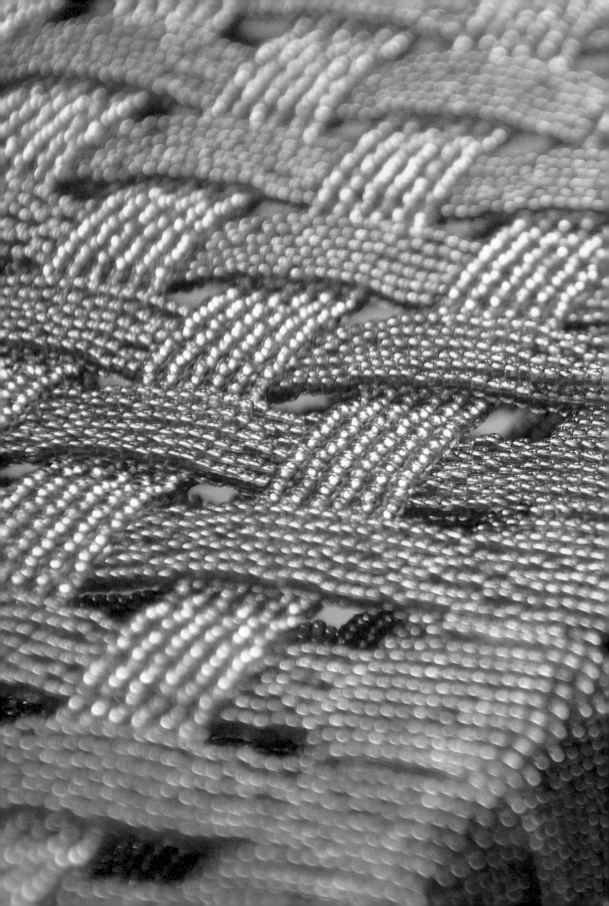

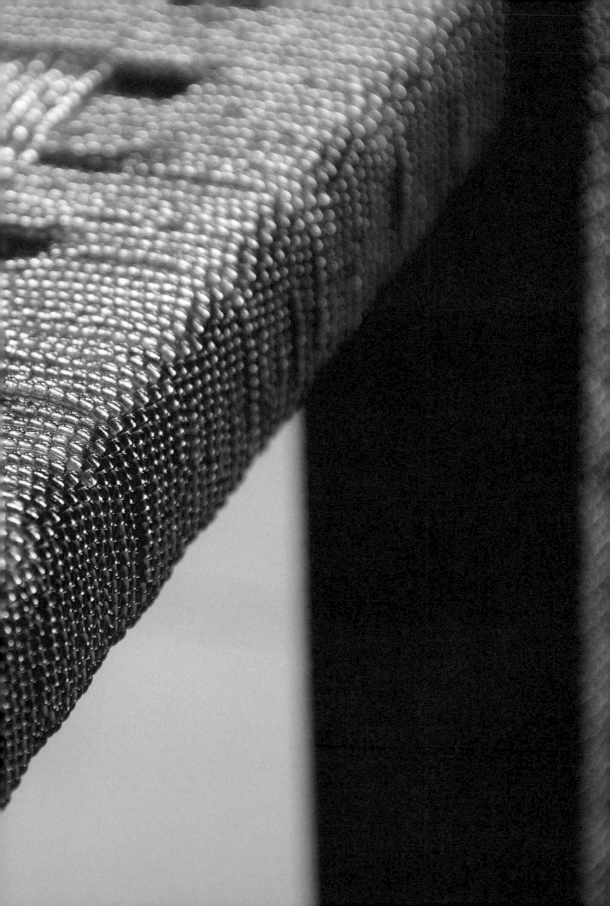

116

Still Life, Shadow 2015
opposite *Reconditioned Stool* 2015

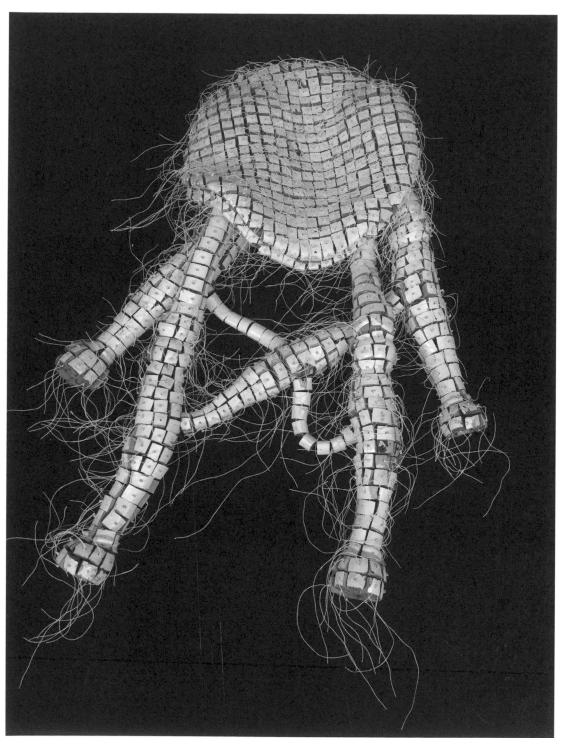

Dropped Necklace II 2016
opposite *Strength in Numbers* 2016

118

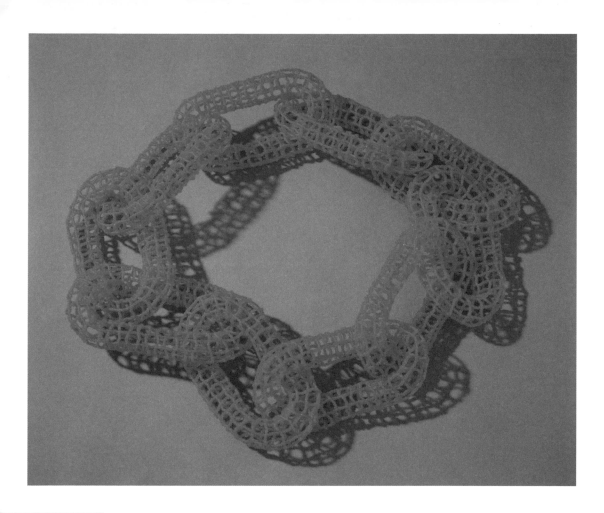

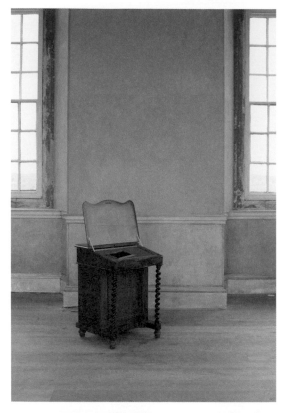

Following research into the history of Wollaton Hall, we explored issues of tension and contradictions within the household and the way social hierarchies were reflected in the architecture. Items of furniture were selected for their association with an activity: a ladder, a writing desk, a music cabinet, a sewing table. Each had small videos of dance set into them that referenced hidden spaces of the building: a strong room, the servants' stairs, the red felt-covered doors. The labour of both servants and the landed gentry reflect the disparities within the household. We thought about the different kinds of labour, the servants' ceaseless, frantic providing for the landowners and their guests, while the labours of the gentry emphasised leisure, such as embroidery or music. Installed in the Prospect Room, with the only access being several flights of spiral stone stairs, the embedded videos contrasted with the expansive views on all sides.

Close Distance, video installation in collaboration with Angela Woodhouse and Nic Sandiland, Wollaton Hall, Nottingham 2017

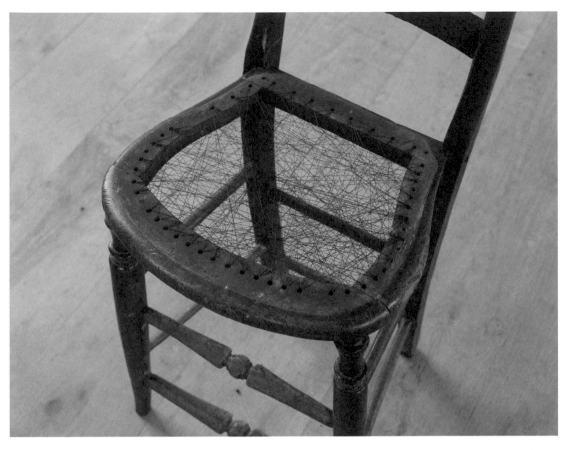

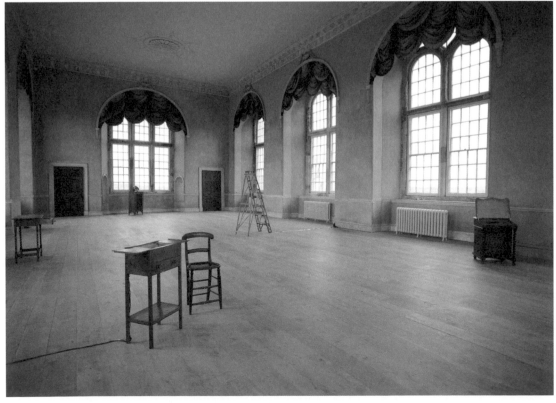

Inside Out 2017

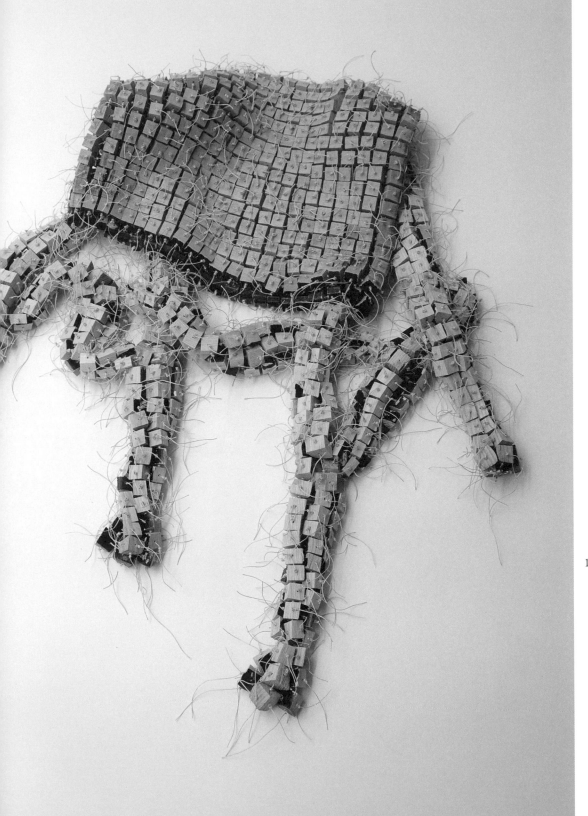

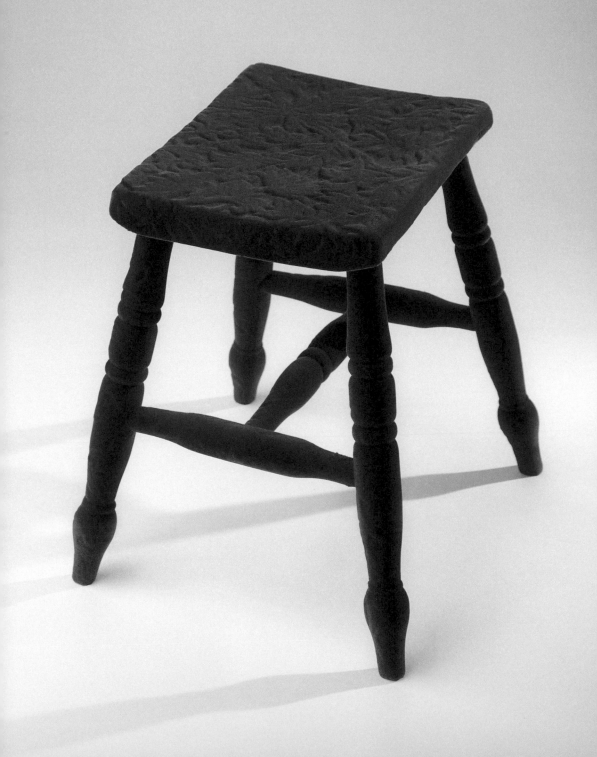

Biography

AWARDS / GRANTS

2017	Lifetime Achievement Award, Goldsmiths' Craft and Design Council
2004	Textile Open, Ormeau Baths, Belfast
1997	Jerwood Prize for Applied Arts: Textiles
1982	Crafts Council Bursary

SOLO / TWO PERSON EXHIBITIONS

2015	*Second Hand First Hand*, with Maria Militsi, Marsden Woo Gallery, London
2014	*Small Change*, WALKA studio, Santiago de Chile
2011	*Taking the Chair*, with Maisie Broadhead, Marsden Woo Gallery, London
2010	*Descubieta*, with Raquel Paienowsky, Ex Teresa Arte Actual, Mexico City
2007	*Exchange of Views*, SOFT, Norske Tekstilkunstnere, Oslo
2006	*New Work*, Marsden Woo Gallery, London
2005	*Breathing Space*, York St Mary's, York
2003	*Away*, Mission Gallery, Swansea; Leeds Metropolitan University Gallery
	Caroline Broadhead, Hå gamle prestegård, Hå kommune, Norway
2001	*Caroline Broadhead*, Barrett Marsden Gallery, London
	Chiaroscuro, Mid Pennine Arts, Burnley
2000	*Between Light and Dark*, Galerie Ra, Amsterdam
1999	*Bodyscape: Caroline Broadhead*, Angel Row Gallery, Nottingham and tour
1983	Galerie Het Kapelhuis, with Betty Woodman
1982	solo show, Galerie Ra
1981	solo show, Arnolfini Gallery, Bristol and tour
1980	*Caroline Broadhead*, Van Reekummuseum, Apeldoorn
1979	*Caroline Broadhead, Michael Brennand-Wood*, Crafts Council Gallery, London

SELECTED GROUP EXHIBITIONS

2015	*Many a Slip*, Marsden Woo Gallery, London
2014	*Finding*, Foundling Museum, London
2012	*Unexpected Pleasures*, Design Museum, London
	Hanging Around, Museum of Art and Design, New York
2011	*Under that Cloud*, Galerie Spektrum, Munich and tour
	Open Mind, Sungkok Art Museum, Seoul
2009	*House of Words*, Dr Johnson's House, London
2008	*Masters and Protégés*, Museum of Arts & Crafts, Itami
2006	*Caroline Broadhead, Andrea Prock, Valie Export*, UBR Gallery, Salzburg
2005	*Fashion and Anti-Fashion*, Museum of Fine Arts, San Francisco
2005	*Body Extensions*, Musée de design et d'arts appliqués contemporains, Lausanne

2004 *The Space Between*, Curtin Gallery, Curtin
 University, Perth
2002 *The Uncanny Room*, Pitzhanger Manor,
 London; Bowes Museum, Co Durham
 Zero Carat, American Craft Museum,
 New York
 Design Mensch, Museum für Kunst und
 Gewerbe, Hamburg
2001 *Caroline Broadhead, Carol McNicol, Irene
 Nordl, Sigurd Bronger*, Bergen Kunsthall,
 Norway
 The Unexpected, Sotheby's, New York
 Designkroppen, Trapholt Museum, Denmark
1999 *Textures of Memory*, Angel Row Gallery,
 Nottingham and tour
 Lifecycles, Galerie für Zeitgenössische
 Kunst, Leipzig
 Weaving the World, Yokohama Museum of Art
1998 *Addressing the Century: 100 Years of Art &
 Fashion*, Hayward Gallery, London and tour
 Beyond Material, Oriel Mostyn, Llandudno
 and tour
 Tempered, Fabrica, Brighton
1996 *Objects of Our Time*, Crafts Council Gallery,
 London and tour
1993 *On the Edge*, Crafts Council Gallery, London
1990 *Three Ways of Seeing* with Richard Slee and
 Fred Baier, Crafts Council Gallery, London
1986 *Conceptual Clothing*, Ikon Gallery,
 Birmingham and tour
1985 *Whitechapel Open*, Christchurch, London
 Body Works and Wearable Sculpture,
 Visual Arts Centre, Alaska
1984 *Crosscurrents*, Powerhouse Museum,
 Sydney
 Jewelry International, Museum of Modern
 Art, Tokyo/Kyoto
1983 *New Departures in British Jewellery*,
 American Craft Museum, New York
1982 *Views on Jewellery 1965–82*, Stedelijk
 Museum, Amsterdam
 Jewelry Redefined, British Crafts Centre,
 London
 Objects of Our Time, American Craft
 Museum, New York
1977 *Design from Britain*, Design Council, British
 Cultural Festival Iran, Tehran; Istfahan
1976/7 *Fourways*, Arnolfini Gallery, Bristol, Galerie
 Ra, Amsterdam, and tour
1975/7 *On Tour 10 British Jewellers in Germany and
 Australia*, Crafts Advisory Committee/British
 Council

RESIDENCIES
2006 Pilchuck Glass School, Seattle
2003 Curtin University of Technology, Perth
2001 Imperial War Museum with video maker
 Peter Anderson, London
1998 ArtRes, Bundesministerium, Vienna

PERFORMANCES / COLLABORATIVE PROJECTS WITH CHOREOGRAPHERS

2017 *Close Distance*, with Angela Woodhouse
 and Nic Sandiland, Wollaton Hall,
 Nottingham, Arts Council of England,
 Nottingham City Council
2010–15 *Between*, with Angela Woodhouse, Laban
 Centre London, Yorkshire Sculpture Park
 and tour
2010 *Censor(ed)*, with Angela Woodhouse,
 commissioned by Woking Dance Festival,
 in collaboration with Tate Artist's rooms
2009–15 *Sighted*, with Angela Woodhouse, Royal
 Opera House, Sadler's Wells, London and
 tour
2005 *Dreams and Ruins*, with Angela Woodhouse,
 Witley Court, Worcestershire
2003–4 *Court*, with Angela Woodhouse, tour
 including Trinity Laban, London; Yorkshire
 Sculpture Park; Sadler's Wells, London
1997 *The Waiting Game*, with Angela Woodhouse,
 Upnor Castle, Kent
1995 *Unlaced Grace*, with Claire Russ, Mill Arts
 Centre, Banbury
1991 *Stranded*, with Rosemary Lee, South Bank
 Centre, London

WORK IN PUBLIC COLLECTIONS
CODA Museum, Apeldoorn; **Crafts Council
Collection**, London; **Dallas Museum of Art**;
Goldsmiths' Hall, London; **Imperial War Museum**,
video collection, London; **Kunstmuseum**, Bayreuth;
Middlesbrough Institute of Modern Art; **The
Museum of Arts and Design**, New York; **Museum
für Kunst und Gewerbe Hamburg**; **The Museum
of Fine Arts, Houston**; **Museum of Modern Art**,
Kyoto; **National Museum of Scotland**, Edinburgh;
Norfolk Museums, Norwich; **Nottingham Castle
Museum**; **Powerhouse Museum**, Sydney; **Racine
Art Museum**, Wisconsin; **Stedelijk Museum**,
Amsterdam; **Sørlandets Kunstmuseum**, Kristiansand;
Nordenfjelske Kunstindustrimuseum, Trondheim;
Ulster Museum, Belfast; **Victoria and Albert
Museum**, London

127

**Caroline Broadhead has taught and lectured widely
and is currently Course Leader BA Jewellery Design
and Programme Director for Jewellery & Textiles at
Central Saint Martins, UAL.**

© 2017 Arnoldsche Art Publishers, Stuttgart, Caroline Broadhead, London, and the authors

All rights reserved. No part of this work may be reproduced or used in any form or by any means (graphic, electronic or mechanical, including photocopying or information storage and retrieval systems) without written permission from the copyright holder Arnoldsche Art Publishers, Olgastraße 137, D–70180 Stuttgart.
www.arnoldsche.com

AUTHORS
Liesbeth den Besten
Caroline Broadhead
Jorunn Veiteberg

TEXT EDITOR
Wendy Brouwer, Stuttgart

PROJECT COORDINATOR
Marion Boschka, Arnoldsche Art Publishers

GRAPHIC DESIGNER
Alida Sayer

OFFSET REPRODUCTIONS
Schwabenrepro, Stuttgart

PRINTED BY
Printed by GTS, Kranj

PAPER
140 gsm Tauro Offset

Printed on PEFC certified paper. This certificate stands throughout Europe for long-term sustainable forest management in a multi-stakeholder process

128

BIBLIOGRAPHIC INFORMATION PUBLISHED BY THE DEUTSCHE NATIONALBIBLIOTHEK
The Deutsche Nationalbibliothek lists this publication in the Deutsche Nationalbibliografie; detailed bibliographic data are available on the Internet at www.dnb.de.

ISBN 978-3-89790-508-5

Made in the European Union 2017

PHOTO CREDITS
Caroline Broadhead; 18 (bottom), 28, 29, 33 (bottom), 36 (bottom), 52 (bottom), 71, 74, 75, 90, 91, 120, 121
Noel Brown; 72
Ray Carpenter; 12 (left)
Jack Cole; 11, 21, 96, 114, 115, 118, 119, 123, 124
David Cripps; 13, 32, 33 (top), 55
Hugo Glendinning; 17, 64, 65, 68, 69, 88, 89, 99, 100, 101, 102, 103, 104, 105
Jerry Hardman Jones; 92, 93
John Hilliard; 40, 41
Ed Ironside; 58, 62, 63
Jonathan Keenen; 112
Gary Kirkham; 18 (top), 80, 81, 82, 83, 87
Gary Kirkham / Angel Row Gallery; 20, 73, 76, 77, 78
Peter Mackertich; 27, 30, 31, 34, 36 (top), 56, 57, 59
Marsden Woo Gallery; 97
Graham Matthews; 86
Karen McDonnell; 79
Tessa Peters; 84
Dominic Richards; 55
Philip Sayer / Marsden Woo Gallery; 8, 23, 108, 109, 110, 111, 116, 117
Philip Sayer / Private Collection; 113
Charles Thomson; 37
David Ward; 4, 12 (right), 14, 15, 35, 38, 42, 43, 44, 45, 46, 47, 48, 49, 50, 51, 52 (top), 53
Simon Webb; 95
Andrew Whittuck; 66, 67
Alistair Wilson; 107

COVER IMAGE
Inside Out, 2017
Photo by Jack Cole

DANCERS
Martina Conti and Stine Nilsen; 103
Henrietta Hale; 107
Matthew Hawkins; 65
Russell Trigg; 64
Stine Nilsen; 98, 99, 101, 102, 103
David McCormack and Marcia Pook; 88, 89
Marcia Pook and Fabio Santos; 17

ual: central saint martins

arnoldsche

South Worcestershire College
Learning Resource Centre
Malvern Campus
Albert Road North
Malvern, WR14 2YH